D1231256

IMAGE AND IMAGINATION

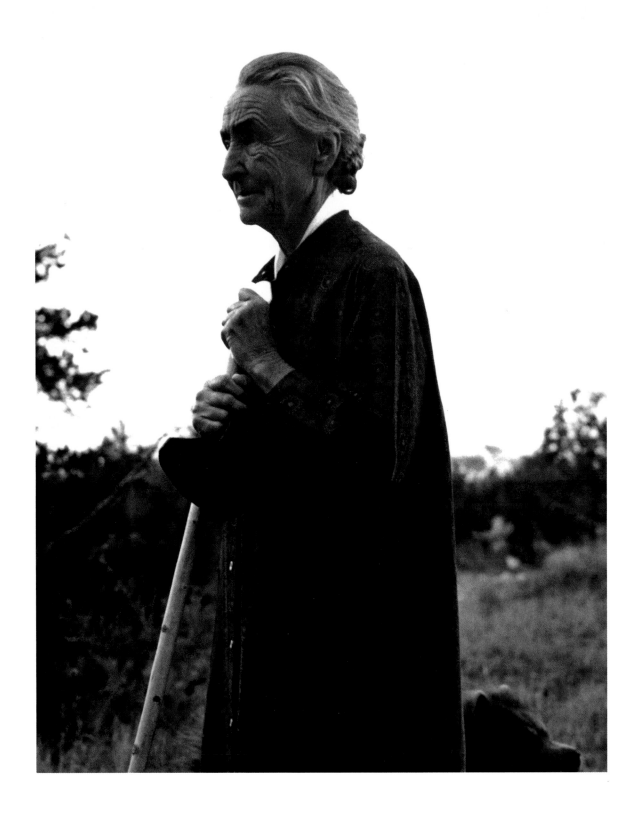

Morning Walk at Ghost Ranch near Abiquiu, New Mexico, 1966

IMAGE AND IMAGINATION

Georgia O'Keeffe
by John Loengard

CHRONICLE BOOKS
SAN FRANCISCO

First published in the United States in 2007 by Chronicle Books LLC.
First published in Germany in 2006 by Schirmer/Mosel.

Authorized U.S. edition by Chronicle Books LLC, San Francisco.
A Schirmer/Mosel Production

Library of Congress Cataloging-in-Publication Data available.
ISBN-10: 0-8118-6132-5
ISBN-13: 978-0-8118-6132-8

Manufactured in Hong Kong

Cover design by Jay Peter Salvas

Distributed in Canada by Raincoast Books
9050 Shaughnessy Street
Vancouver, British Columbia V6P 6E5

10 9 8 7 6 5 4 3 2 1

Chronicle Books LLC
680 Second Street
San Francisco, California 94107

www.chroniclebooks.com

Preface

In June 1966, John Loengard visited Georgia O'Keeffe at her house in Abiquiu and on Ghost Ranch in New Mexico, a 30-minute drive away. He had been asked by *Life* magazine to take photographs for an article on the artist. At the time Georgia O'Keeffe was 78 years old and a legendary figure in American art. She had lived out in the desert of New Mexico for 30 years, moving there in 1946 after the death of her husband, photographer Alfred Stieglitz.

Back then the mills of photojournalism must have ground even slower than they do today, for 15 months later in October 1967, John Loengard traveled to New Mexico again for the *Life* article, this time accompanied by art critic Dorothy Seiberling.

Georgia O'Keeffe's 80th birthday was just around the corner, and clearly the previously abandoned story had now advanced to become a possible cover story and birthday serenade. John Loengard's task was to shoot a strongly visual cover photograph.

On November 15, 1967 the artist's 80th birthday came and went, but the magazine did not make use of the occasion. Not until March 1 the following year did *Life* feature as its cover story: 'Georgia O'Keeffe – Strong Visions of a Pioneer Painter' – the story ran 16 of the 39 photographs included in this book.

Occasionally, the mills of art book publishers grind even more slowly than those of photo-journalism. The desire to unite photographs by John Loengard with selected paintings by Georgia O'Keeffe in a book came to me spontaneously when I first set eyes on Loengard's portfolio in 1993. You could say it was my formative experience with O'Keeffe, whose paintings I had not really managed to appreciate properly previously. Though very familiar with them as phenomena of American contemporary art they had, nonetheless, remained alien to me. John Loengard's photographs altered that at one blow. They showed me how realistically and accurately Georgia O'Keeffe's painterly creations refer to the landscape and the things she saw in her immediate surroundings. Even someone who has never witnessed New Mexico's desert before suddenly realizes that the reality of the desert is burned into these surreal images. Every-thing in Georgia O'Keeffe's paintings is intertwined with external reality in a quite amazing way – mountains, deserts, or the interiors of her houses.

As the most "lofty" example of such interlacing I cite the ladder leading to the roof of Ghost Ranch (Plate 32), which features as a hovering celestial stairway in the painting *Ladder to the Moon* (Plate 31).

A sudden magic is articulated by everyday things – bones, stones, a rattlesnake's rattle, the ladder, patio, house and landscape. John Loengard's photographs evoke it and it is disclosed in painterly form in Georgia O'Keeffe's images. The silent dialog between the imaginations of the real and the reality of the imaginary, against the background of the desert where bones have become the symbol of death and life, is unprecedented in art.

In 1994, I had to abandon my plan to wed photographs by John Loengard with paintings by Georgia O'Keeffe in a single book, because it was not then possible to secure the rights for such a project from the O'Keeffe estate. Initially, I published John Loengard's photographs separately. It is a wonderful book that captures a day in the artist's life from her morning walk to her evening walk, but it does only show one side of the coin. Now some 12 years after the first attempt, I am delighted to be able to present the project as originally planned with the paintings by Georgia O'Keeffe I had already selected back then.

As you can judge for yourself, the passage of time has by no means been detrimental either to the book or its topic. The editors of *Life* made a similar experience in their dealings with Georgia O'Keeffe and her work – and long before I did. Perhaps the desert is to blame for that, which measures time differently from our hectic metropolises.

Lothar Schirmer

A Visit with Georgia O'Keeffe

Georgia O'Keeffe greeted me cordially at her door in Abiquiu, New Mexico in June 1966. A retrospective of her paintings had opened in Fort Worth, Texas, that spring and was touring the country. *Life* magazine had decided to do a story on the painter and her work. They asked me to go and photograph her. O'Keeffe had a reputation of living as a hermit – suffering no fools gladly and journalists not at all. Although my visit was arranged through her representative in New York, I was wary.

'How much time will you need to take your pictures?' O'Keeffe asked.

'A couple of days,' I answered.

'*Life* is only planning a little story,' she said.

'That depends on how good the pictures are,' I told her, which was true.

'I don't know. Let's see ...' she answered, and proceeded to give me a tour of the house, introduced me to her handyman, and let me follow as she drove her four-door, white Lincoln Continental to her other home at Ghost Ranch, half an hour away. There she introduced me to her cook-housekeeper, and offered me lunch.

I was looking for something unexpected. I wanted to interest her in what I was doing and set the tone for what might follow. I had kept my cameras in their bag until lunch-time. At the table O'Keeffe began to talk of killing rattlesnakes on her walks about the property and pulled out boxes filled with rattles from a sideboard.

'May I take a picture?' I asked.

'Of course,' she answered.

I photographed her hand as she moved rattles about the box with a matchstick. I figured O'Keeffe would like *Life*'s readers to see she was a killer.

Certainly she did not want to be shown painting pictures. She said that would be a photographic cliché. Indeed, the reason she had let me visit when I did was that she was not painting. (Her most recent canvas showed clouds as she'd looked down on them from a jet plane on her way to Indonesia.) In fact, we did not talk about painting much, and we didn't talk about photography at all. If she mentioned her late husband, it was

likely in a reference to household problems – like organizing the laundry – at the Stieglitz family's summer house at Lake George, New York. I was 32, and she was 79, and she seemed happy to have a young man about if we talked of anything but her work or mine. She talked a great deal, often with amusement. O'Keeffe played the role not so much of a painter, but of a wealthy woman, interested in the arts. She paid considerable attention to the smooth management of her household.

On each of the three days I photographed her, O'Keeffe took a thirty-minute walk at dawn and another in the evening. In between she might garden at Abiquiu (she was concerned with eating fresh, natural foods). She'd answer letters, or chat with people who came by. A man stopped in whom she'd known as a boy when he lived on another part of Ghost Ranch; her housekeeper's nephew needed advice on a personal problem; O'Keeffe's sister Claudia, from Beverly Hills, came to visit.

Clearly, O'Keeffe was no hermit. My only notes contain three or four other names I am not certain belong to what visitor – and a short list of items:

- Leonard Baskin (holds book by – seated on bed in Abiquiu).
- Bread has own baked.
- Rattlesnakes rattle collection. Walking stick used to kill.
- Saws (collection of).
- Fake flower from Neiman-Marcus (in bedroom).
- File of photographs of paintings (difficulty of keeping records on all her paintings).

In truth, drawing out a subject's personality is exhausting. Doing so resembles the Scottish game of curling. Scots and Canadians play it on a rink like one for hockey, with a large granite stone and a broom. It is a strange game. You walk in front of a gliding stone, sweeping the ice with a broom. The swept ice guides the stone. I confess I've never played, but it all looks like what I feel when I photograph. I am agreeable. I don't project my personality because I don't want to photograph my subject's reflection of me – but at the same time, I have to lead – sweep the ice and make the person follow the path I've brushed. At the slightest sign of annoyance or impatience, it's sweep, sweep, sweep, and smooth it out. It can be exhausting.

I watched O'Keeffe with a passion to see how light fell on her, to see if she'd repeat a gesture, or to wait for her to move her head a bit this way or that – all the time wondering if what she was doing really made a good picture? At other times I asked O'Keeffe to pose, and she was willing to do that and was very graceful at it.

I was there to take pictures, not notes, but I remember how things went: they went very well. I enjoyed her company, and I felt she enjoyed mine. After photographing the rattlesnakes' rattles at lunch the first day, I left to take a drive around the countryside and get my bearings. I didn't want to be underfoot at Ghost Ranch when nothing was going on that I wanted to photograph. We'd agreed that I should go back to my hotel in Santa Fe, some 75 miles away, and come back at dawn to photograph her morning walk.

Next morning, after the walk, we went over to Abiquiu where she showed me files she used to keep track of the whereabouts of all her paintings. We visited a friend of hers, a Dominican monk who was building a chapel in Chams, but I found no pictures there. We returned to Ghost Ranch, where she wrote letters. Her sister arrived and I left.

O'Keeffe had an errand to do at Abiquiu the next morning, so that's where I met her. She showed me her collection of rocks, bragging that she'd stolen her favourite stone from Eliot Porter, the photographer. She gardened, and I made portraits of her in her bedroom. In the afternoon, we went back to Ghost Ranch, where I photographed her evening walk.

On my last day I drove out to Abiquiu to say goodbye. O'Keeffe was with the director of a museum that would be the next to exhibit her retrospective, but she was not eager to have me do more than look in. I did so and left.

A layout of my photographs wasn't done for 15 months after I returned to New York. (*Life* sometimes worked very slowly.) When it was finished, at the end of October 1967, Dorothy Seiberling, the magazine's art editor, and I went out to New Mexico so Seiberling could get quotes, and so I might take a picture for the magazine's cover.

I was happy to see O'Keeffe again, but the roof at Ghost Ranch was the only place I could think of to photograph her that I hadn't used before. As she sat before a chimney and talked to Seiberling, I took some pictures. I felt they were good. I also felt the curling game had ended, and I'd won.

John Loengard, 1994

When I came to New Mexico in the summer of 1929, I was so crazy about the country that I thought, how can I take part of it with me to work on? There was nothing to see in the land in the way of a flower. There were just dry white bones. So I picked them up. People were pretty annoyed having their cars filled with those bones. But I took back a barrel of bones to New York. They were my symbol of the desert, but nothing more. I haven't sense enough to think of any other symbolism. The skulls were there and I could say something with them … To me they are as beautiful as anything I know. To me they are strangely more living than the animals walking around – hair, eyes and all, with their tails switching. The bones seem to cut sharply to the centre of something that is keenly alive on the desert even though it is vast and empty and untouchable – and knows no kindness with all its beauty.

Georgia O'Keeffe

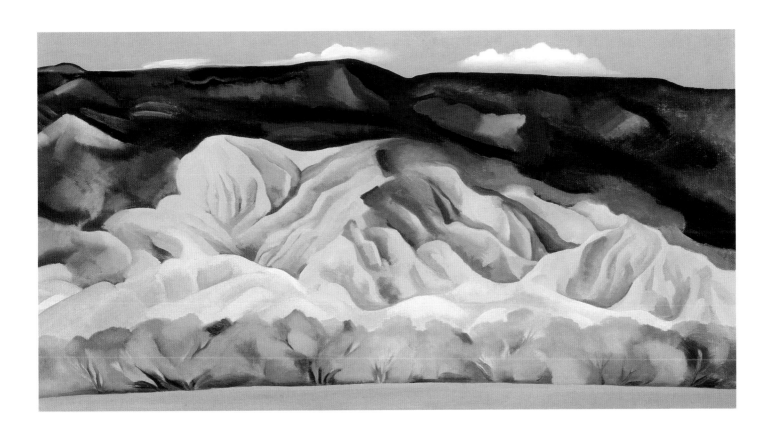

1 *Back of Marie's N° IV*, 1931
Georgia O'Keeffe Museum, Santa Fe/Art Resource/Scala, Florence
40,6 x 76,2 cm

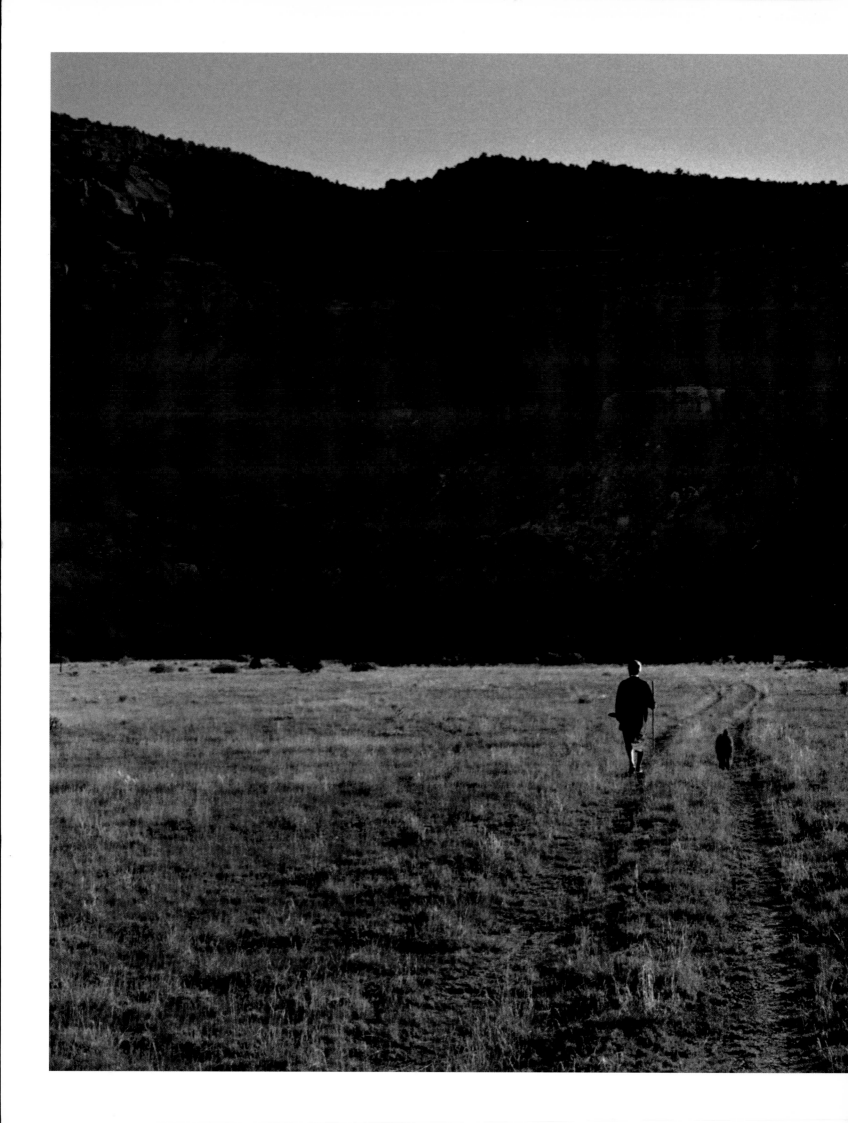

2 Morning Walk,
Ghost Ranch, 1966

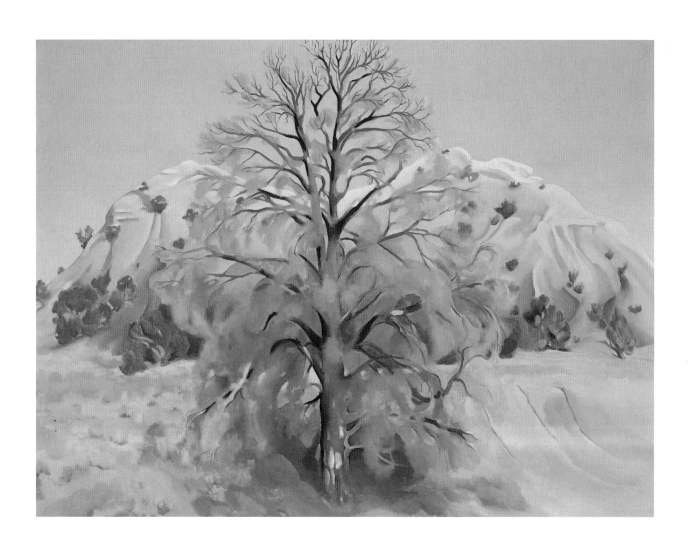

3 *Dead Tree with Pink Hill*, 1945.

The Cleveland Museum of Art, bequest of Georgia O'Keeffe 1987.138

76,5 x 101,6 cm

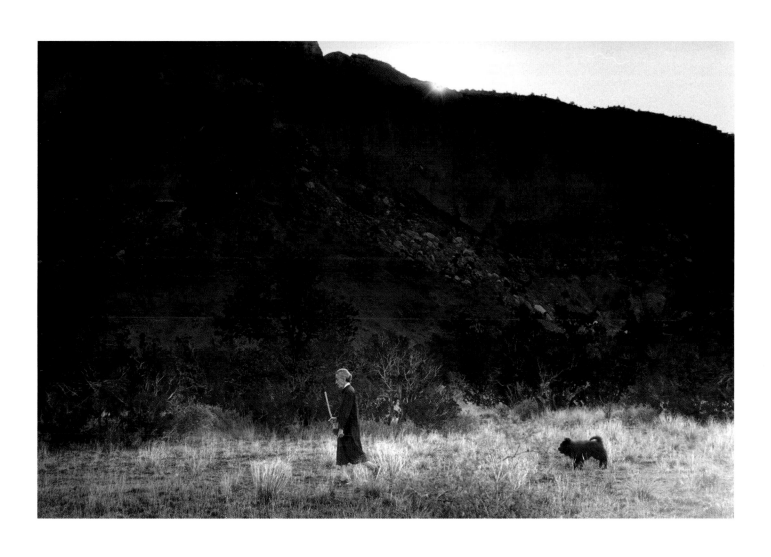

4 Morning Walk, 1966

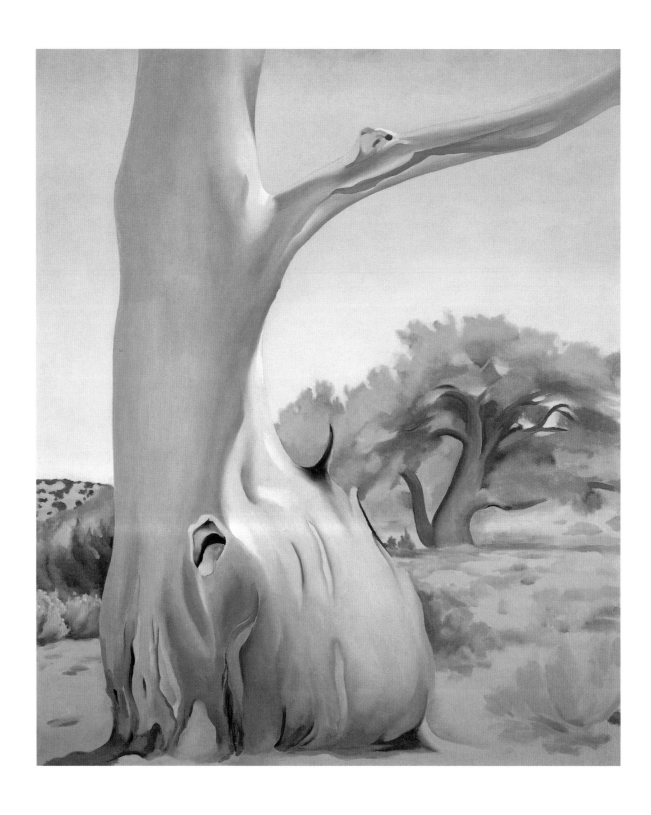

5 *Dead Cottonwood Tree*, 1943
Santa Barbara Museum of Art, gift of Mrs. Gary Cooper
91,4 x 76,2 cm

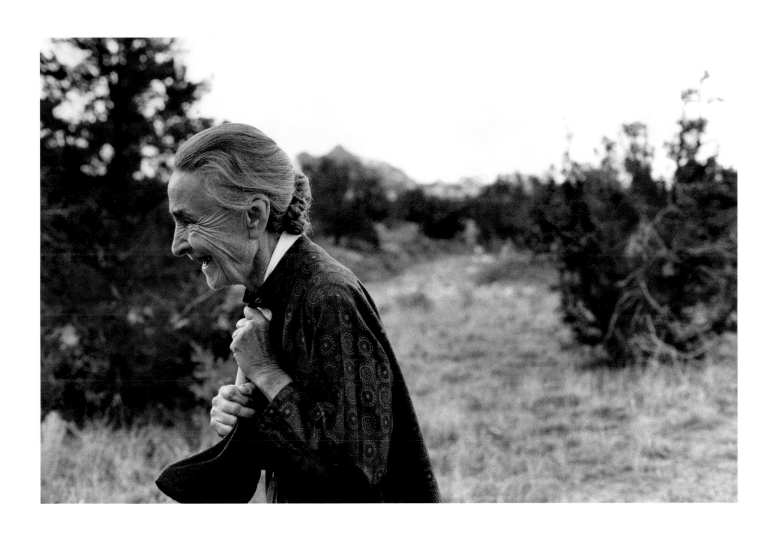

6 Morning Walk, Ghost Ranch, 1966

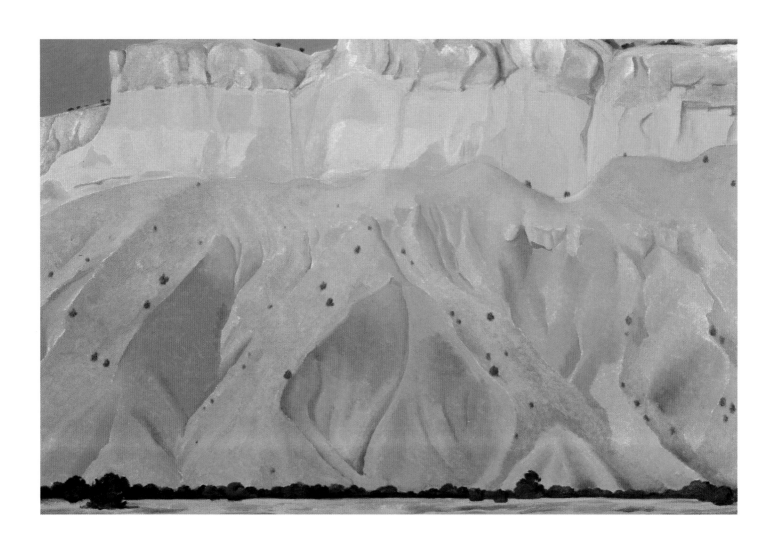

7 *Untitled (Red and Yellow Cliffs)*, 1940
Georgia O'Keeffe Museum, Santa Fe/Art Resource/Scala, Florence
61 x 91,4 cm

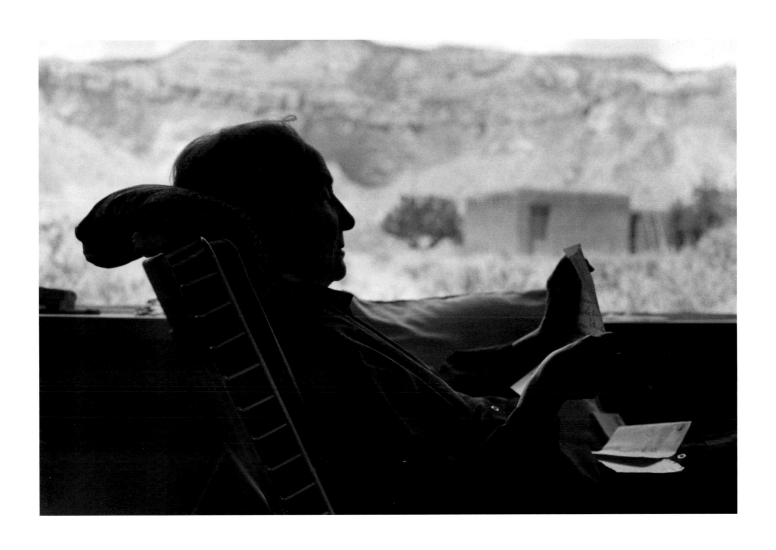

8 Reading letters, Ghost Ranch, 1966

9 Ghost Ranch, 1966

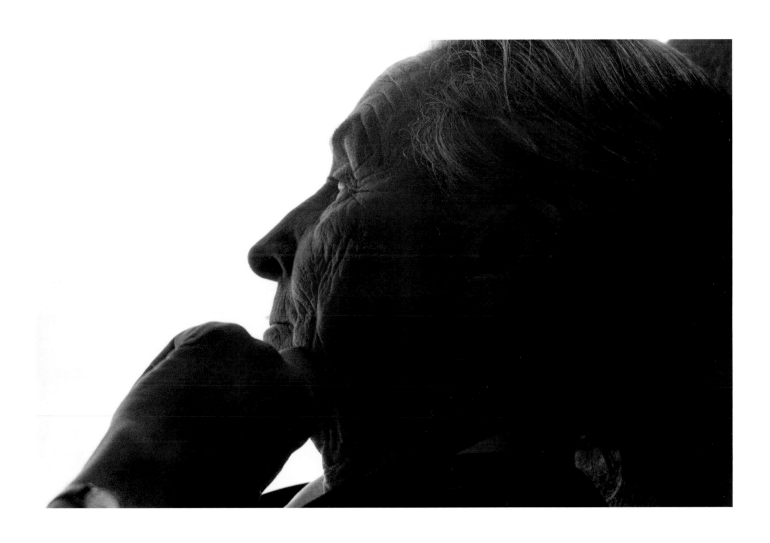

10 Ghost Ranch, 1966

I'm a newcomer to Abiquiu, that's one of the lower forms of life. The Spanish people have been here since the 18th century. The house was a pigpen when I got it in 1946. The roof was falling in, the doors were falling off. But it had a beautiful view.

I wanted to make it my house, but I'll tell you the dirt resists you. It is very hard to make the earth your own. The ranch is really home to me. I've done much less to try to make it mine. All my association with it is a kind of freedom. Yet it's hard to live at the ranch. When I first came here, I had to go 70 miles on a dirt road to get supplies. Nobody would go by in two weeks. I thought the ranch would be good for me because nothing can grow here and I wouldn't be able to use up my time gardening. But I got tired of canned vegetables so now I grow everything I need for the year at Abiquiu. I like to get up when the dawn comes. The dogs start talking to me and I like to make a fire and maybe some tea and then sit in bed and watch the sun come up. The morning is the best time, there are no people around. My pleasant disposition likes the world with nobody in it.

For years in the country the pelvis bones lay about … always underfoot - seen and not seen as such things can be. … I do not remember picking up the first one but I remember … knowing I would one day be painting them. … When I started painting the pelvis bones I was most interested in the holes in the bones — what I saw through them — particularly the blue from holding them up in the sun against the sky as one is apt to do when one seems to have more sky than earth in one's world. … I have no yen to go anywhere. But I go around the world anyway to see what's there — and to see if I'm in the right place. Flying to Japan, the first thing I saw was a field of snow that you could walk on, then a sky paved with clouds. … Wherever I go, I have an eye out for rocks. Outside my hotel in Phnom Penh I picked up a stone and carried it back around the world in my purse. … Stones, bones, clouds — experience gives me shapes — but sometimes the shapes I paint end up having no resemblance to the actual experience.

Georgia O'Keeffe

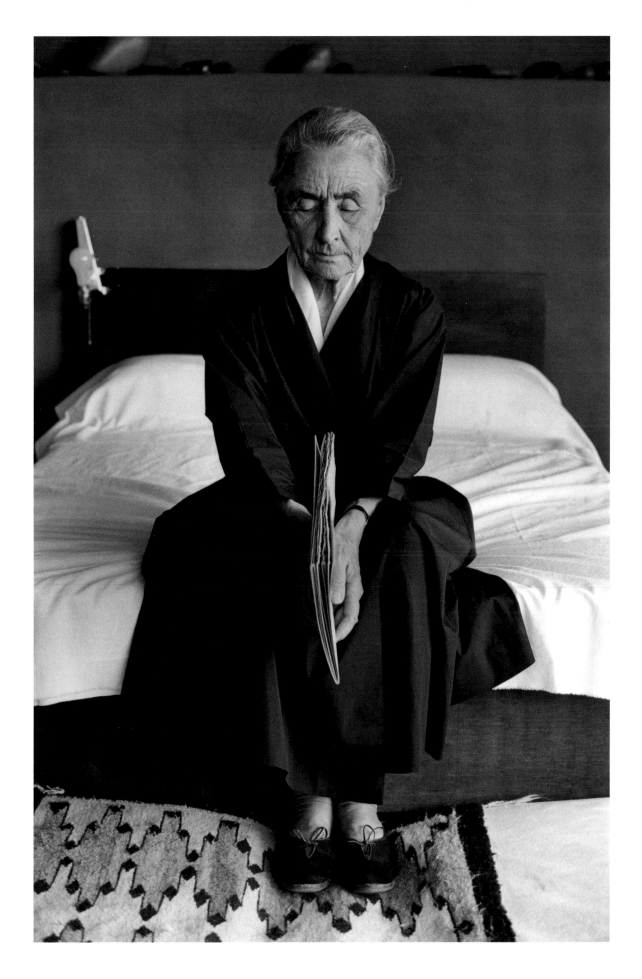

11 Holding a book by Leonard Baskin, bedroom, Abiquiu, 1966

12 *Winter Road I*, 1963
National Gallery of Art, Washington
55,9 x 45,7 cm

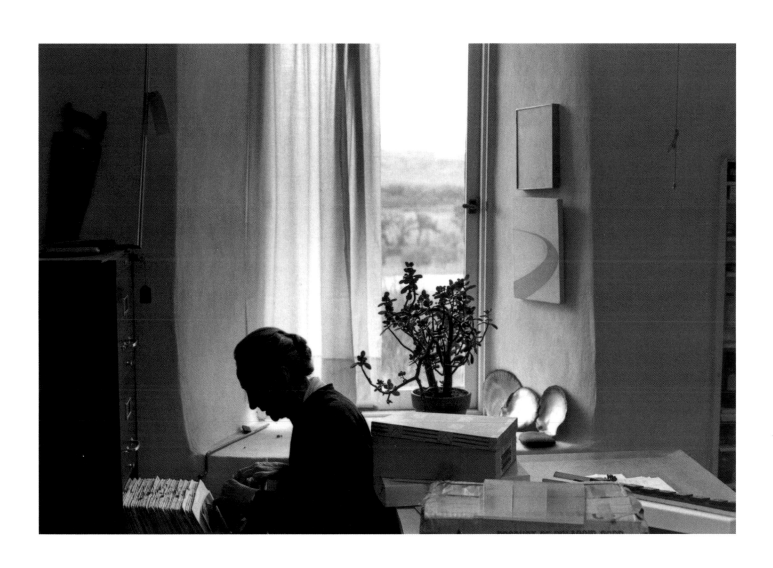

13 Working on the files, Abiquiu, 1966

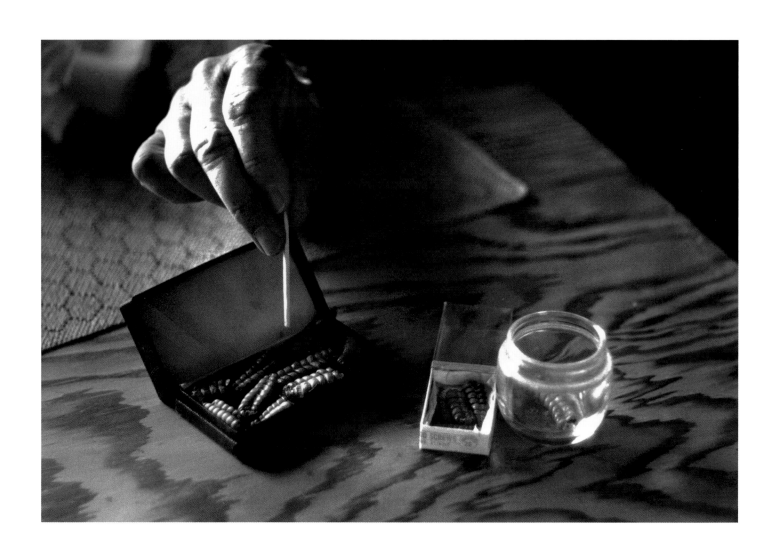

14 Rattlesnake rattles, Ghost Ranch, 1966

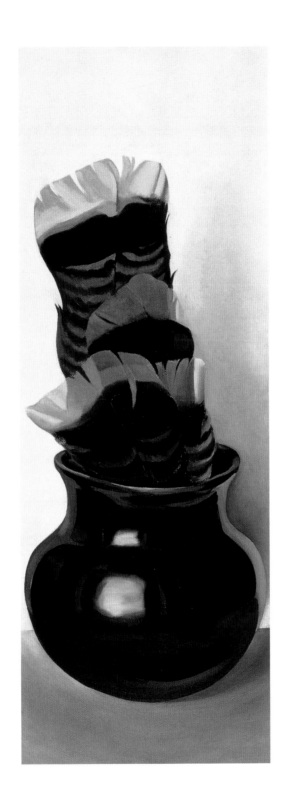

15 *Turkey Feathers in an Indian Pot*, 1935
Private Collection
61 x 21,6 cm

16 *White Patio with Red Door*, 1960
Curtis Galleries, Minneapolis, MN
121,9 x 213,4 cm

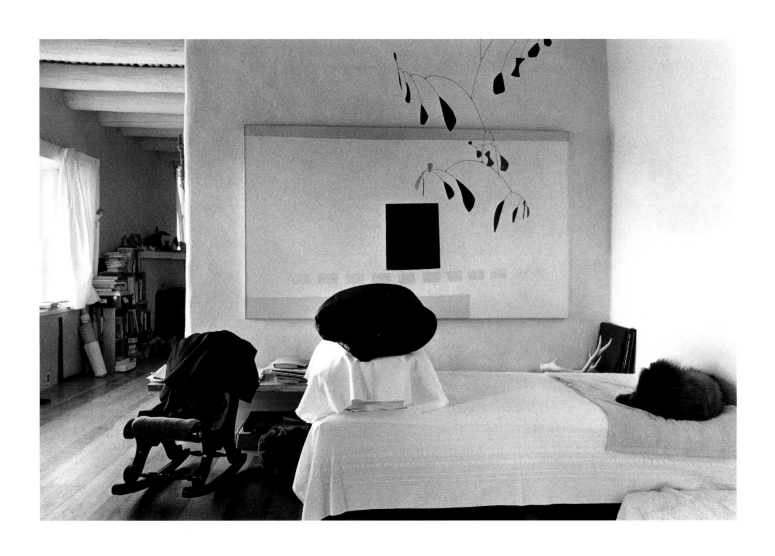

17 Bedroom, Ghost Ranch, 1966

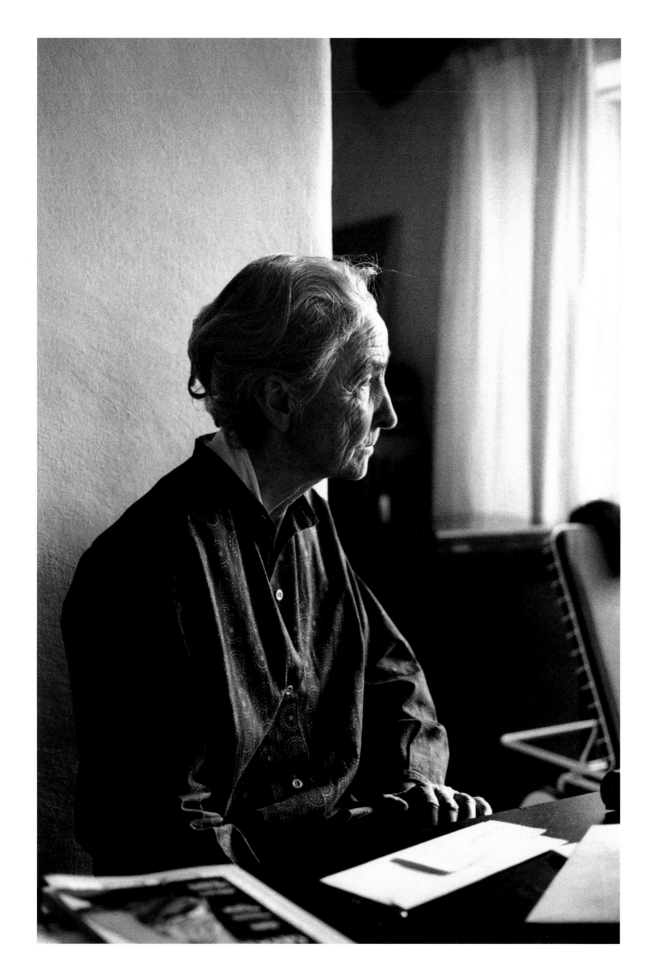

18 Writing letters, Ghost Ranch, 1966

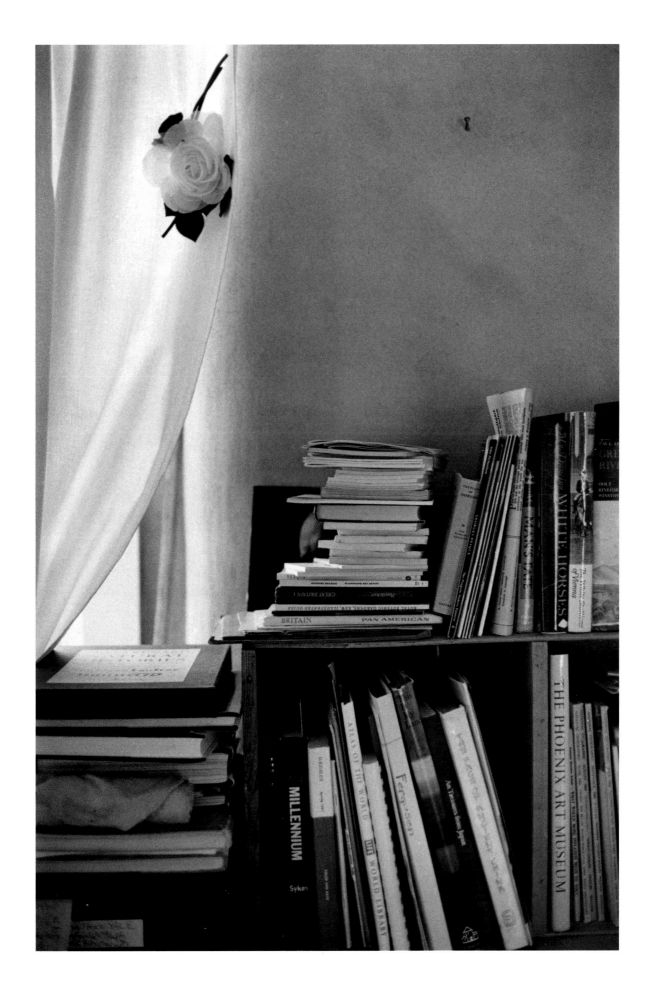

19 Ghost Ranch, 1967

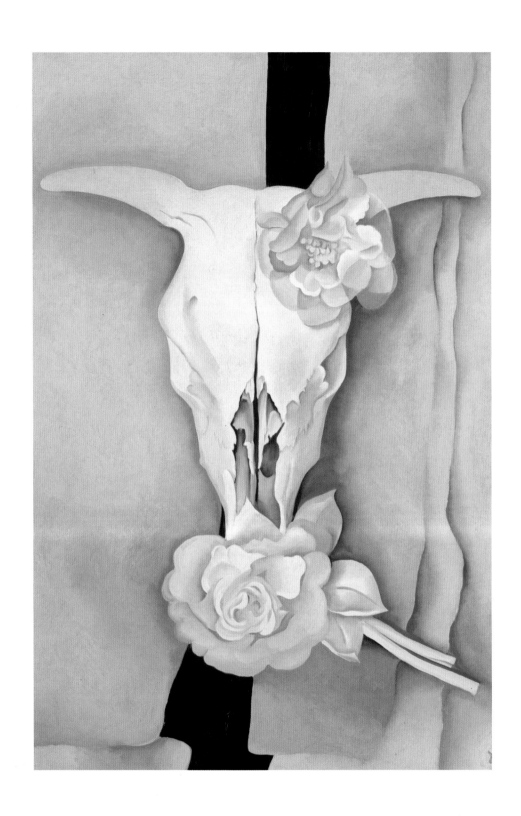

20 *Cow's Skull with Calico Roses*, 1931
The Art Institute of Chicago, Alfred Stieglitz Collection, gift of Georgia O'Keeffe, 1947.712
91,4 x 61 cm

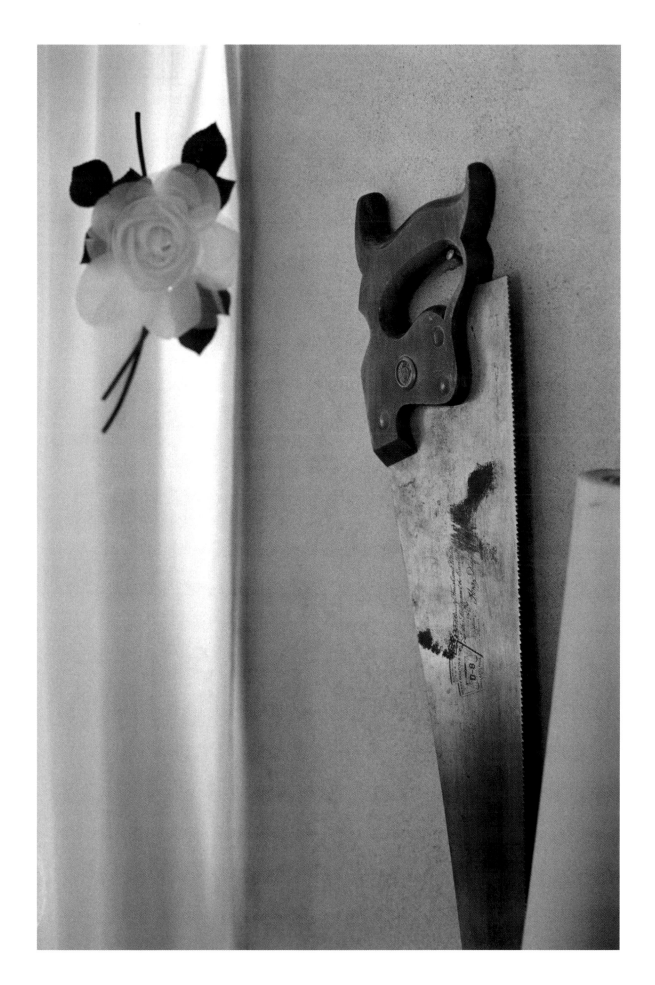

21 Ghost Ranch, 1966

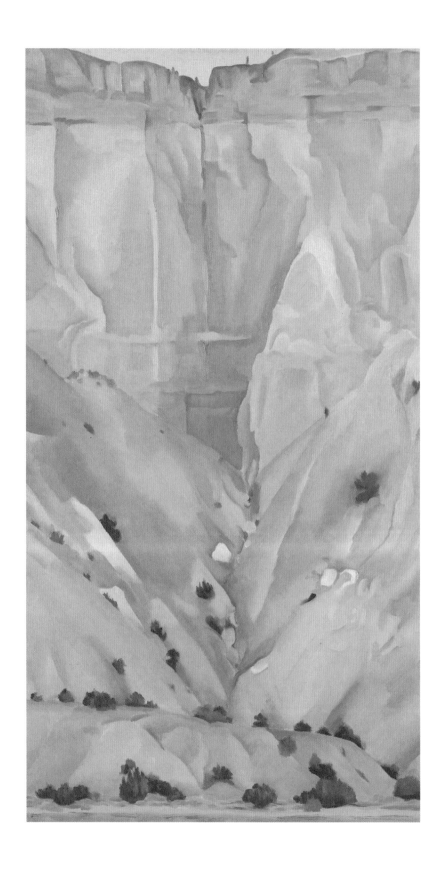

22 *Cliffs Beyond Abiquiu, Dry Waterfall*, 1943
The Cleveland Museum of Art, bequest of Georgia O'Keeffe 1987.141
76,2 x 40,6 cm

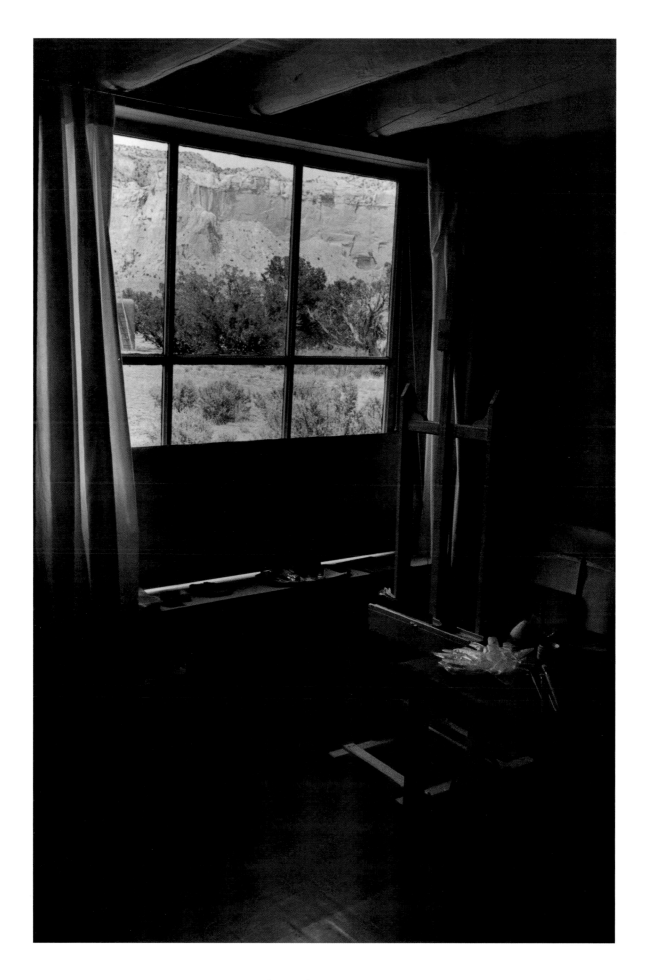

23 Studio, Ghost Ranch, 1966

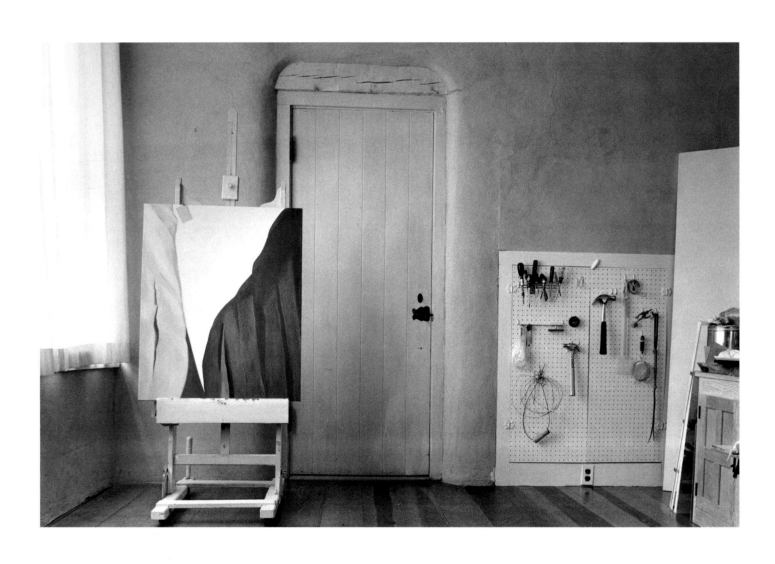

24 Studio, Ghost Ranch, 1967

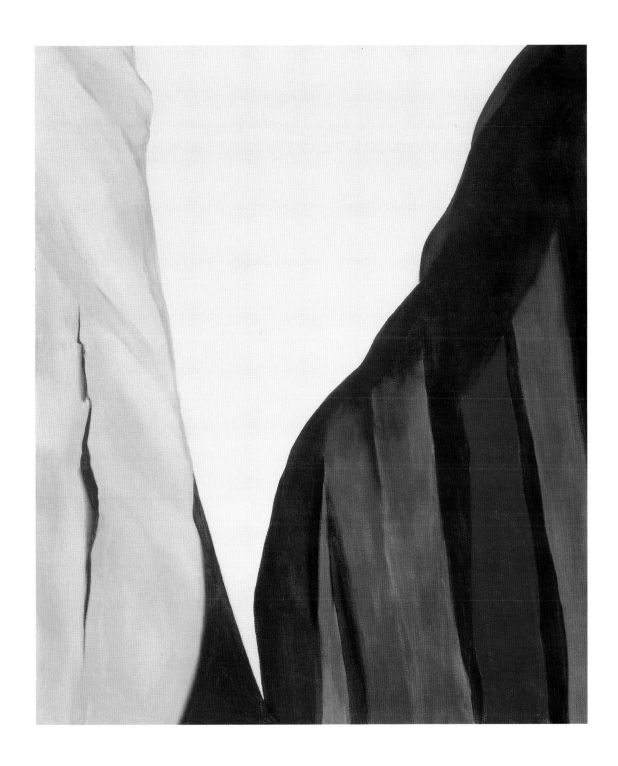

25 *Canyon Country, White and Brown Cliffs*, 1965
Georgia O'Keeffe Museum, gift of the Georgia O'Keeffe Foundation
91,4 x 76,2 cm

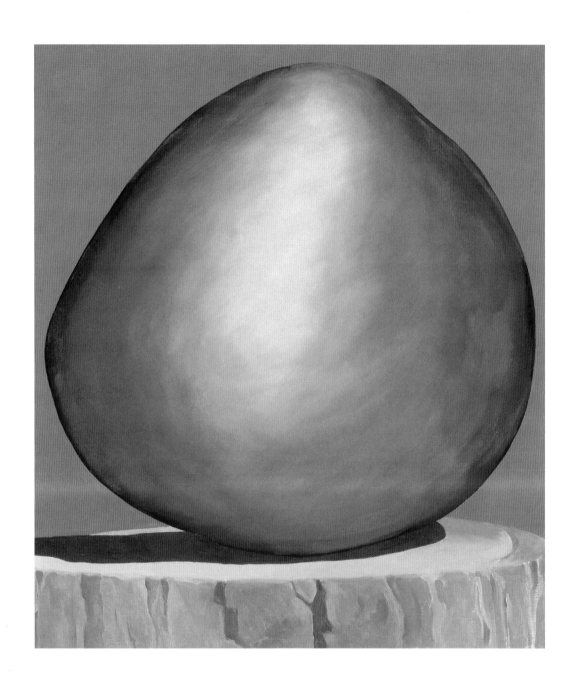

26 *Black Rock on Red*, 1971
Georgia O'Keeffe Museum, Santa Fe/Art Resource/Scala, Florence
76,2 x 66 cm

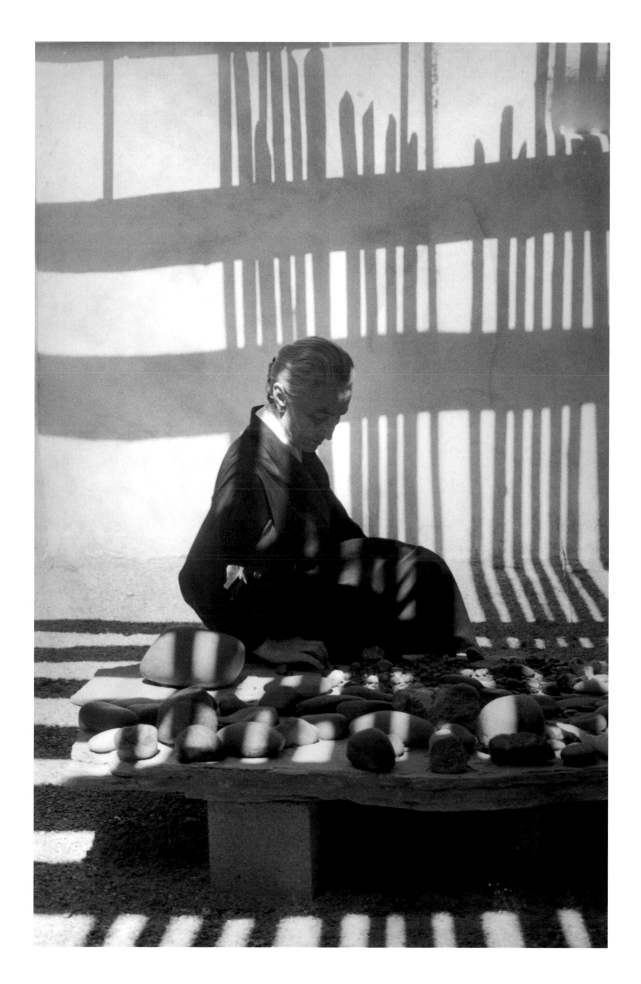

27 With rock collection, Abiquiu, 1966

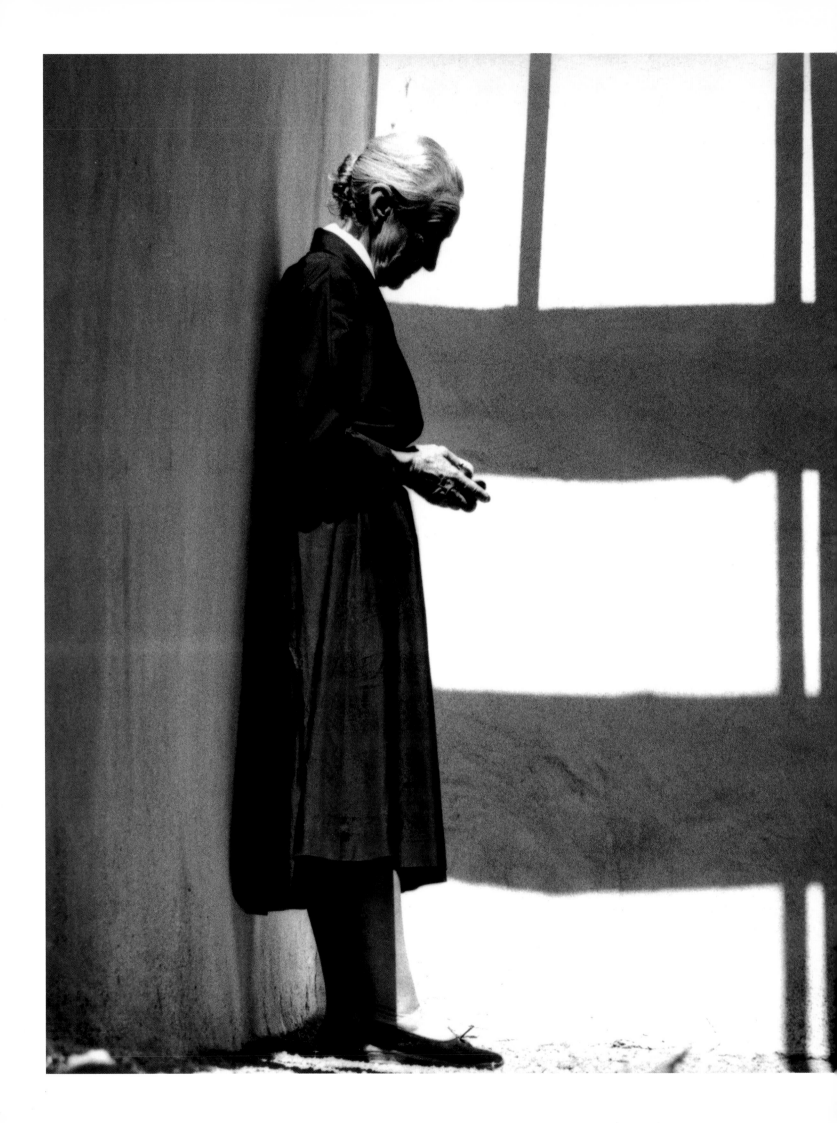

28 Abiquiu, 1966

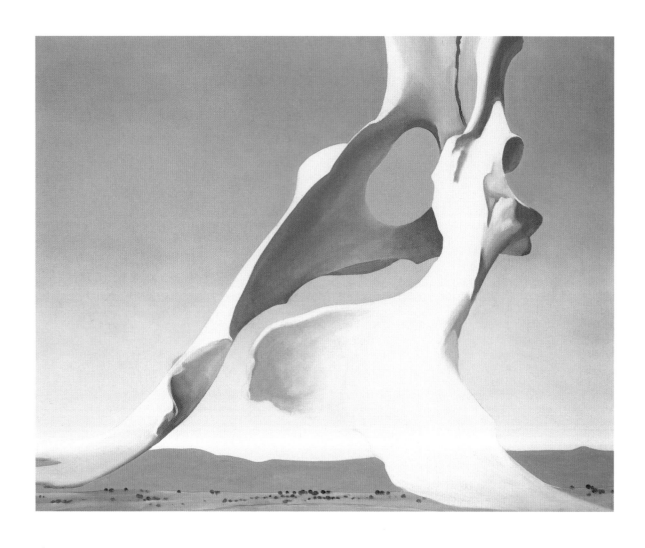

29 *Pelvis with Distance*, 1943
Indianapolis Museum of Art, gift of Anne Marmon Greenleaf
in memory of Caroline Marmon
60,6 x 75,6 cm

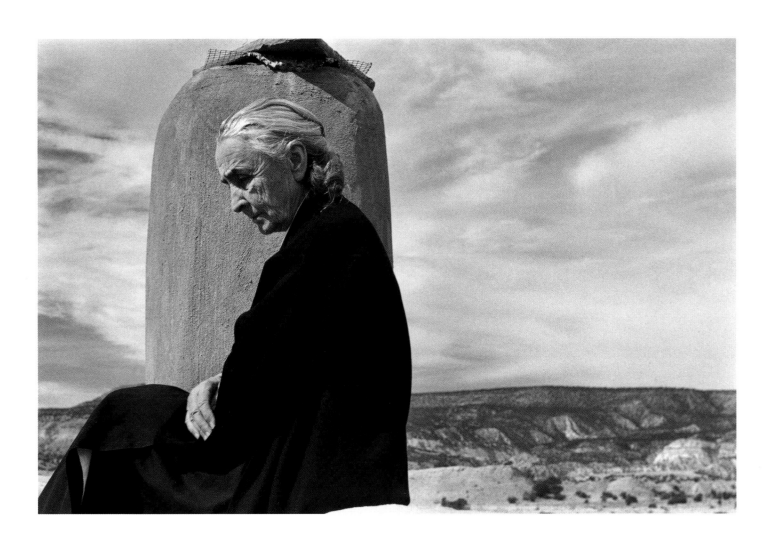

30 On the roof, Ghost Ranch, 1967

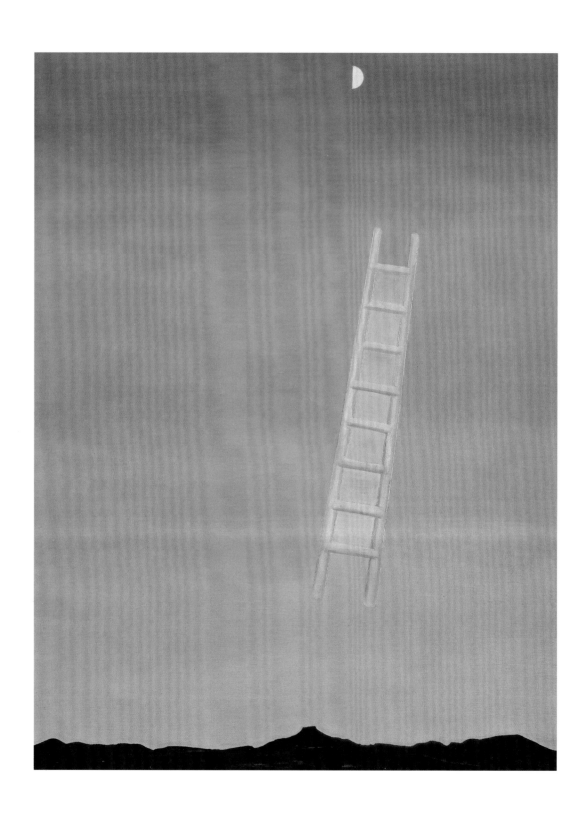

31 *Ladder to the Moon*, 1958
Collection Emily Fisher Landau, New York
101,6 x 76,2 cm

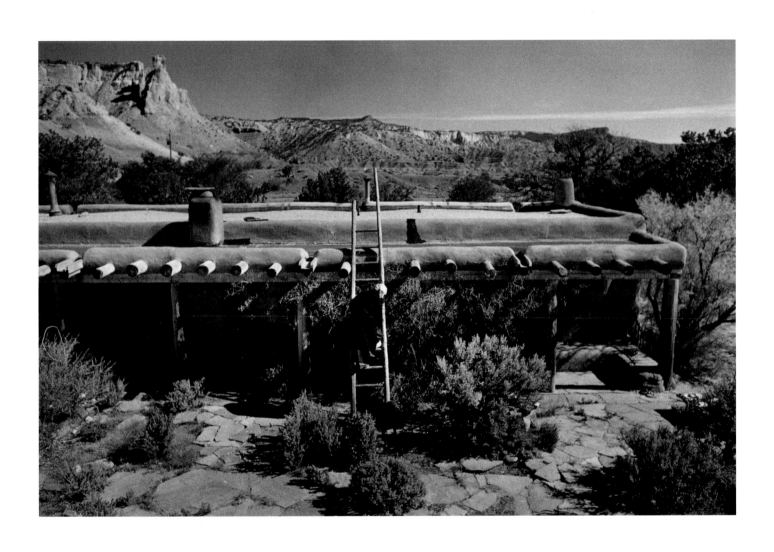

32 Ghost Ranch, 1967

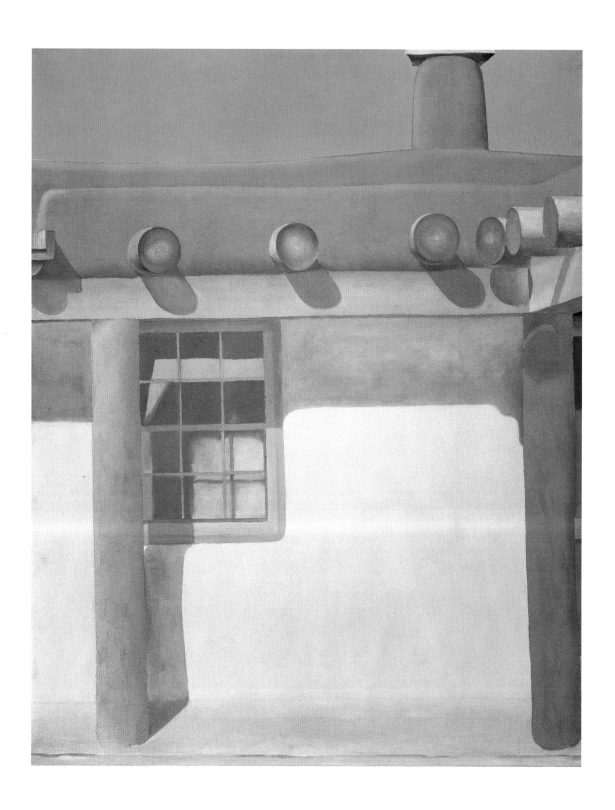

33 *From the Patio N° II*, 1940
Private Collection
61 x 48,5 cm

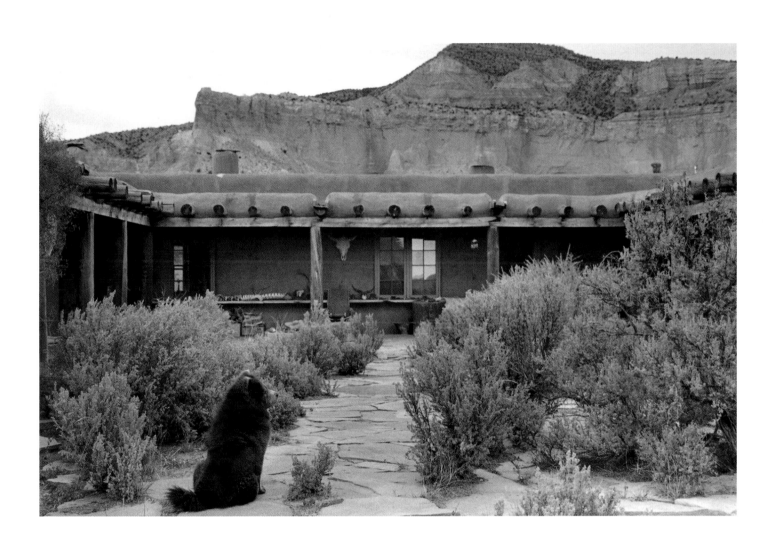

34 Ghost Ranch, 1967

35 Courtyard, Ghost Ranch, 1967

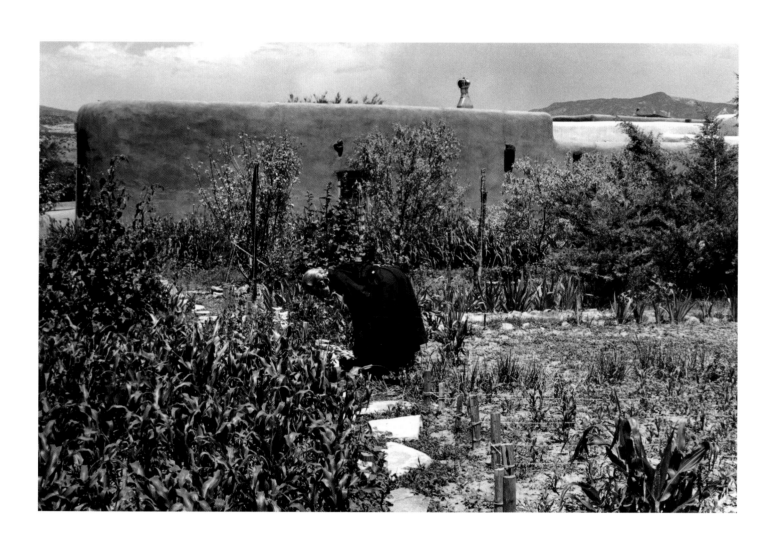

36 Gardening, Abiquiu, 1966

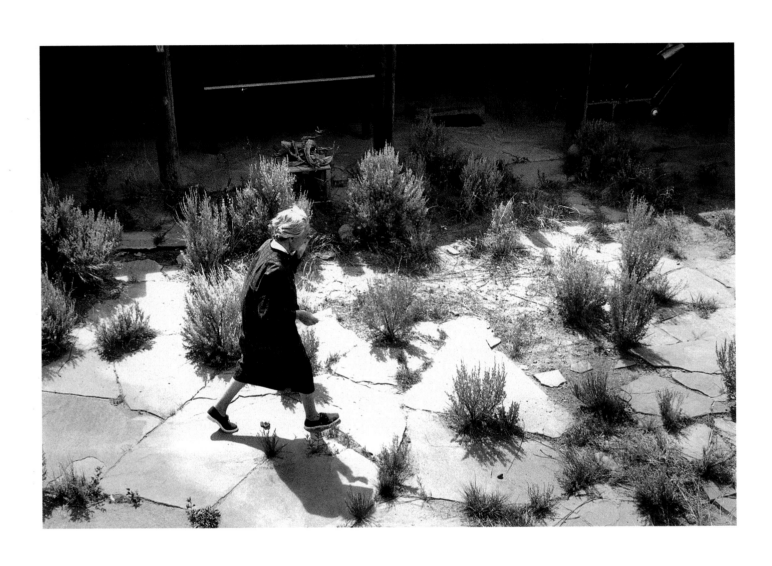

37 Courtyard, Ghost Ranch, 1967

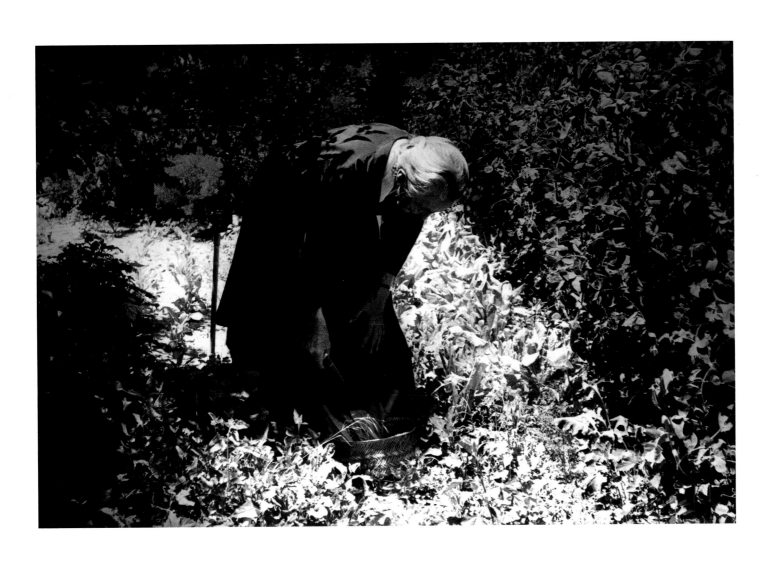

38 Gardening, Abiquiu, 1966

39 *Patio with Black Door*, 1955
Museum of Fine Arts, Boston, gift of William H. Lane Foundation, 1990.433
101,6 x 76,2 cm

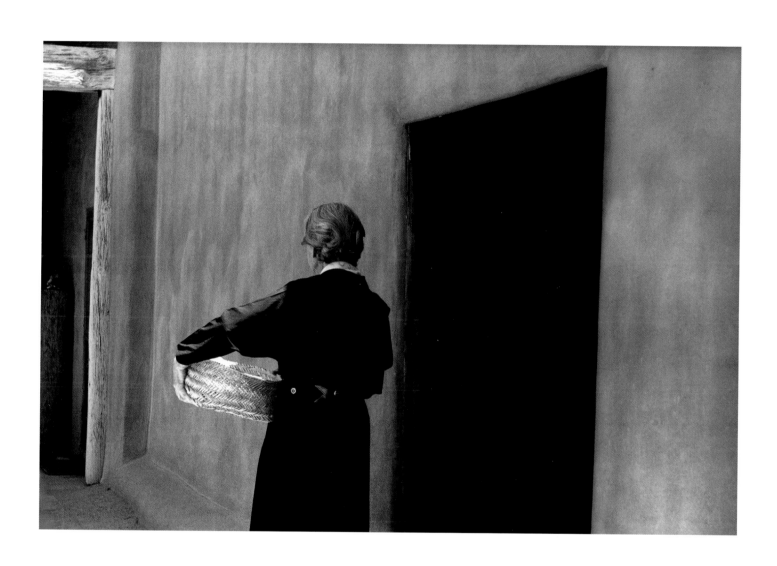

40 Abiquiu, 1966

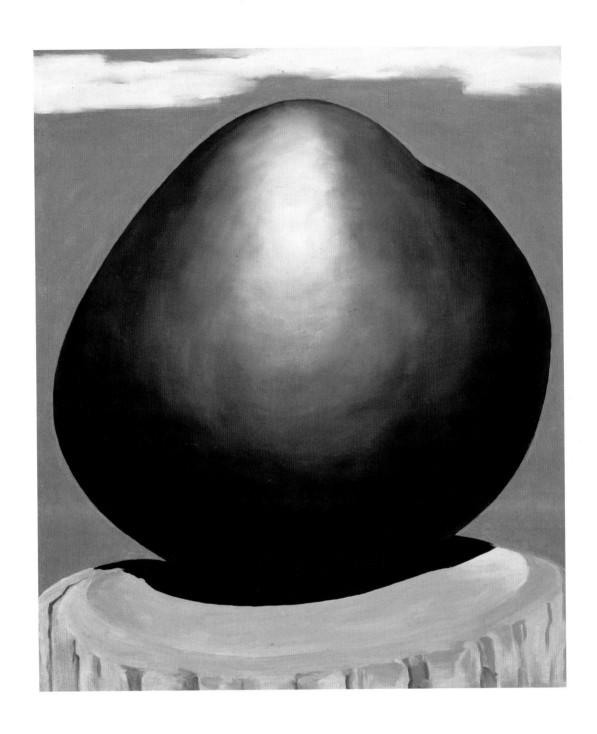

41 *Black Rock with Blue Sky and White Clouds*, 1972
The Art Institute of Chicago, Alfred Stieglitz Collection, bequest of Georgia O'Keeffe, 1987.250.3
91,4 x 76,2 cm

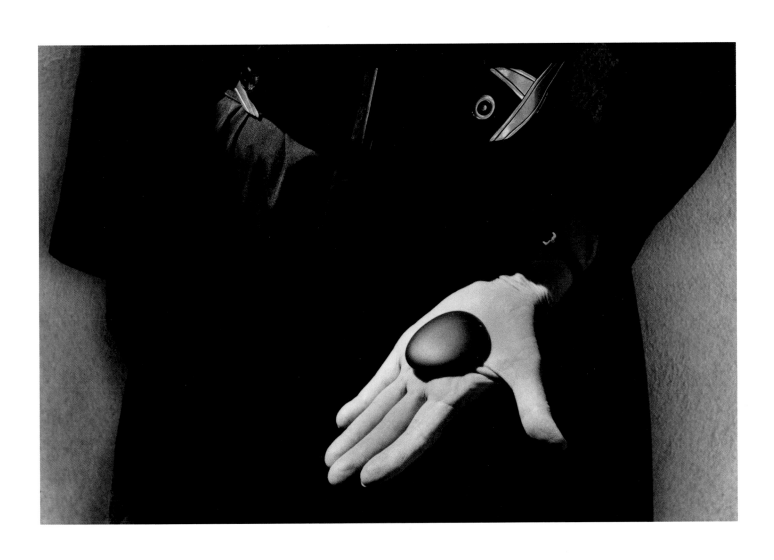

42 Holding Eliot Porter's rock, Abiquiu, 1966

43 *Patio with Cloud*, 1956
Milwaukee Art Museum, gift of Mrs. Edward R. Wehr, M1957.10
91,4 x 76,2 cm

44 Abiquiu, 1966

45 *In the Patio Nº IV*, 1948
Museum of Fine Arts, Boston, gift of William H. Lane Foundation, 1990.434
33,6 x 76,2 cm

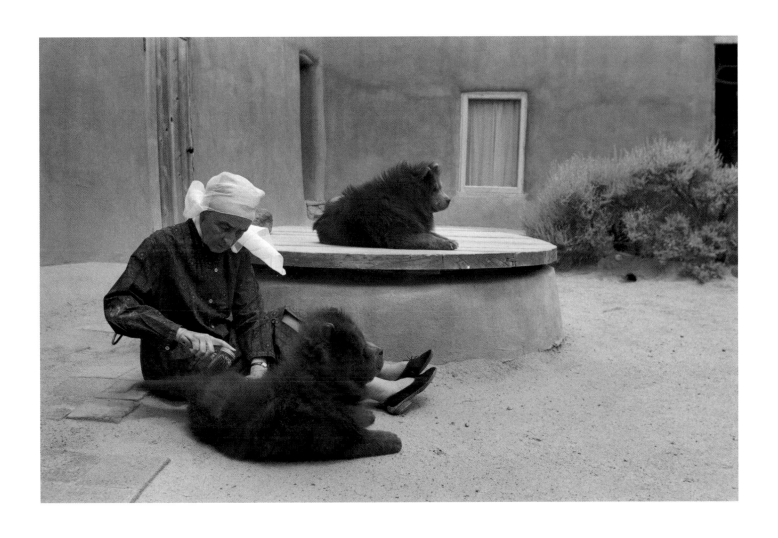

46 Grooming dogs, Abiquiu, 1966

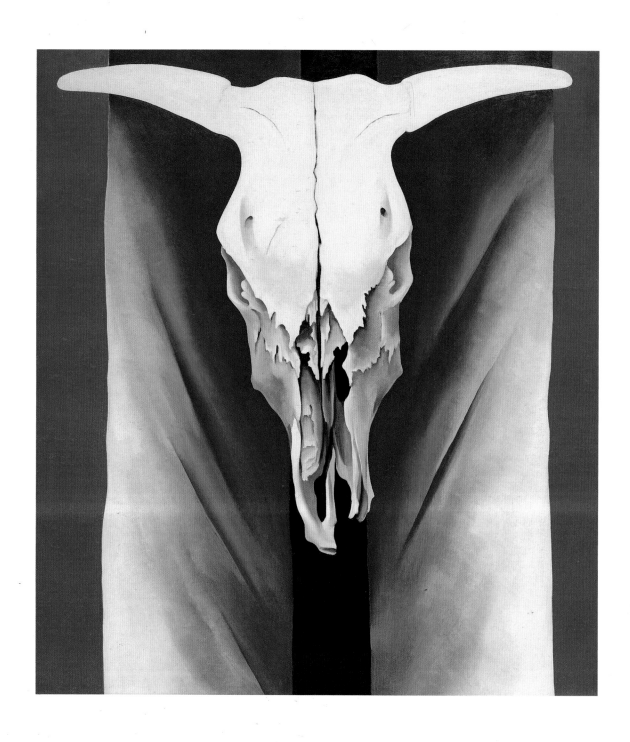

47 *Cow's Skull: Red, White and Blue*, 1931
The Metropolitan Museum of Art, Alfred Stieglitz Collection, 1952 (52.203)
101,3 x 91,1 cm

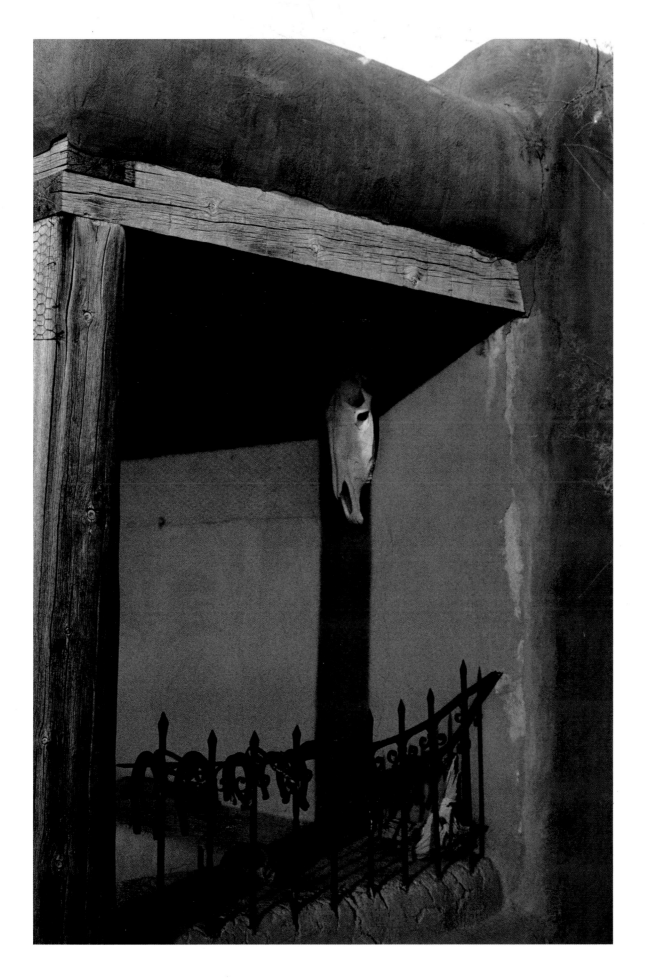

48 Ghost Ranch, 1967

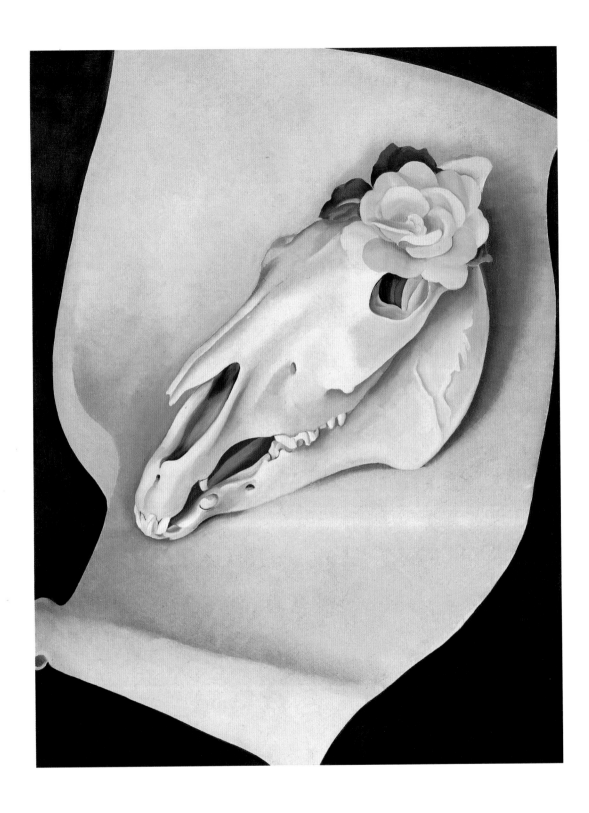

49 *Horse's Skull with Pink Rose*, 1931

Museum Associates/LACMA, gift of Georgia O'Keeffe Foundation

101,6 x 76,2 cm

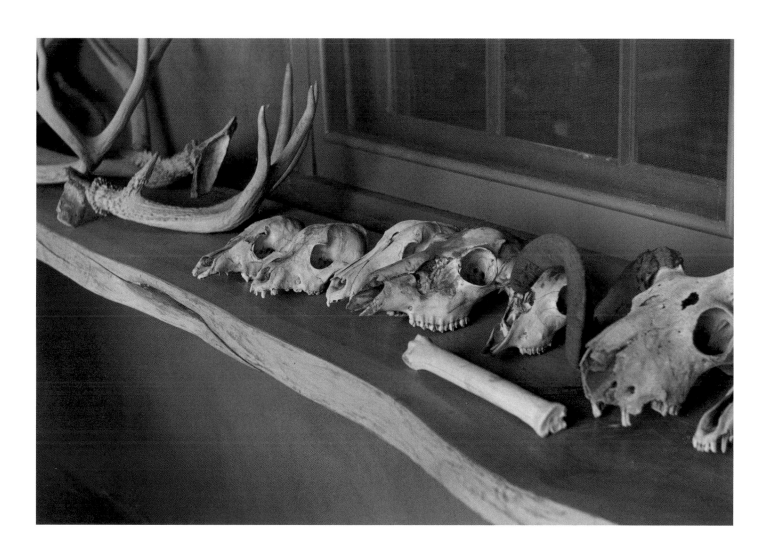

50 Ghost Ranch, 1966

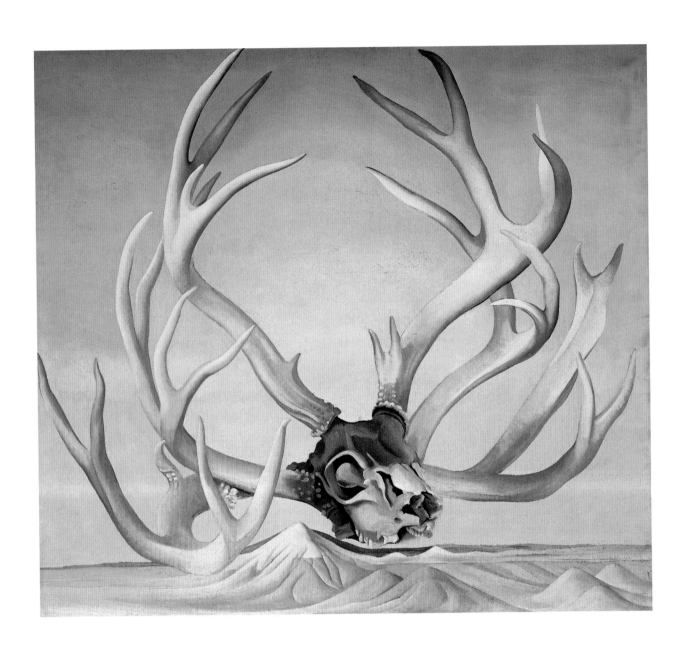

51 *From the Faraway Nearby*, 1938
The Metropolitan Museum of Art, Alfred Stieglitz Collection, 1959 (59.204.2)
91,4 x 101,9 cm

52 Ghost Ranch, 1966

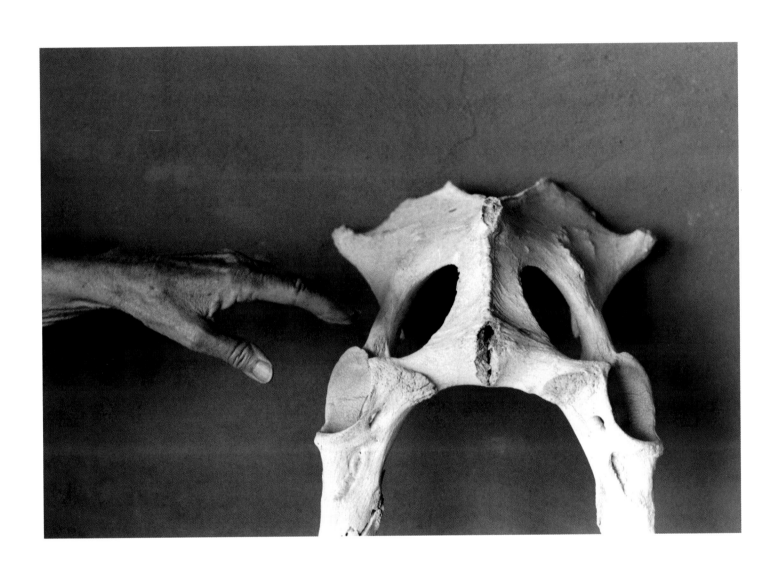

53 Ghost Ranch, 1966

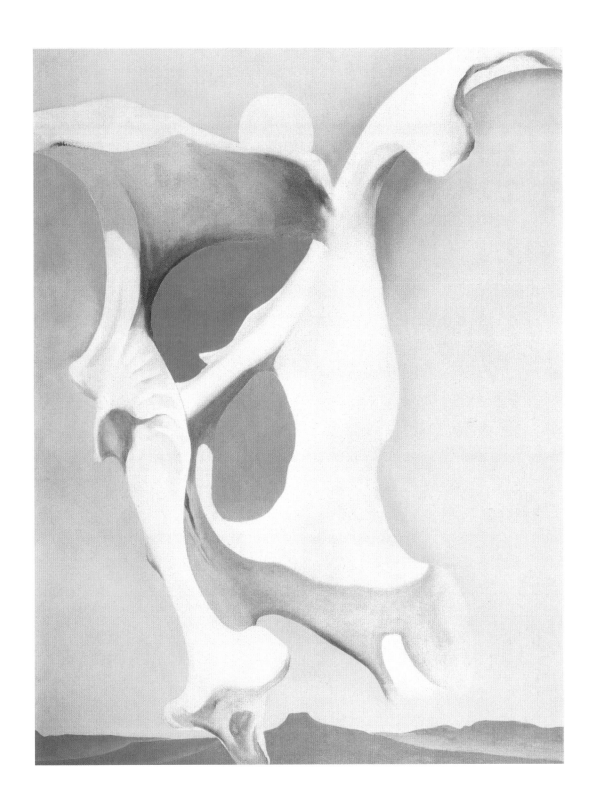

54 *Pelvis with the Moon*, 1943
© Norton Museum of Art, West Palm Beach, Florida
76,2 x 61 cm

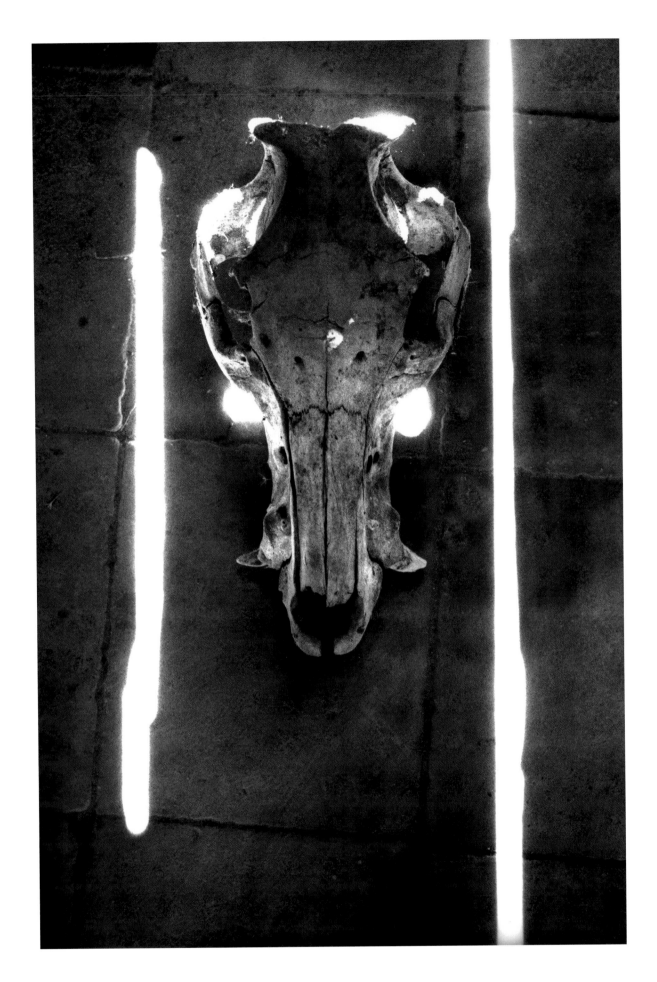

55 Pig Skull, Abiquiu, 1966

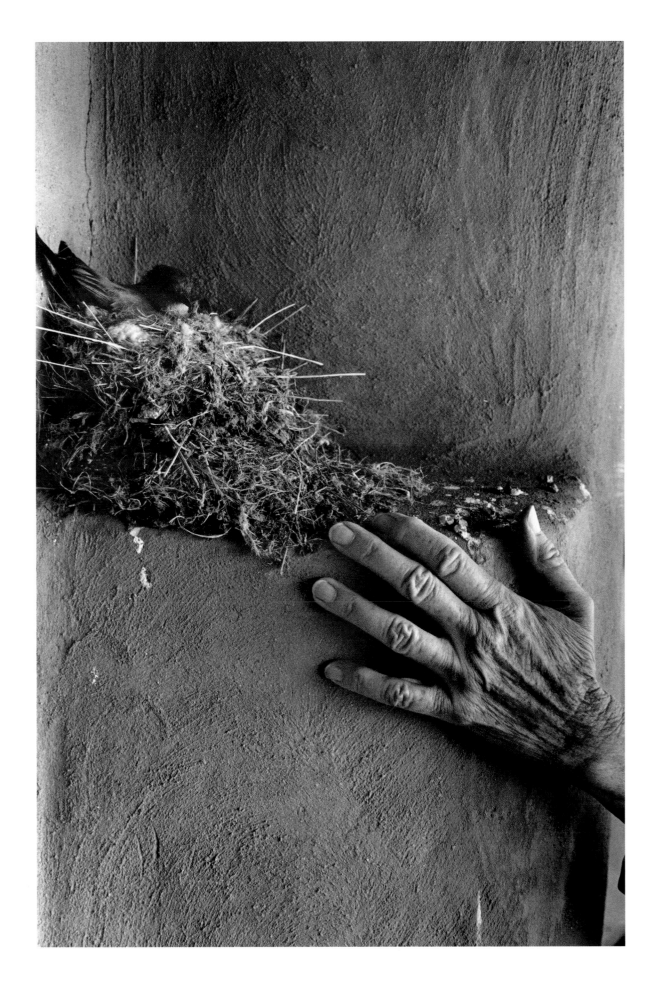

56 Ghost Ranch, 1966

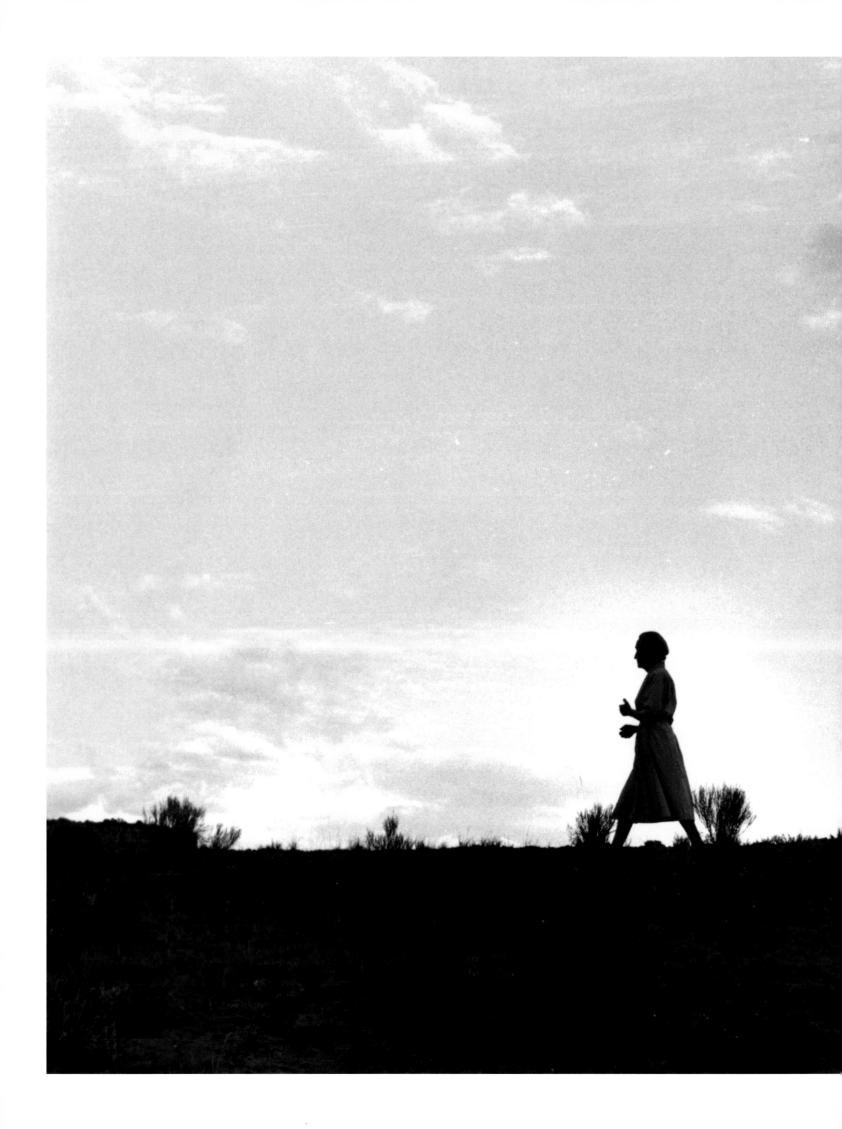

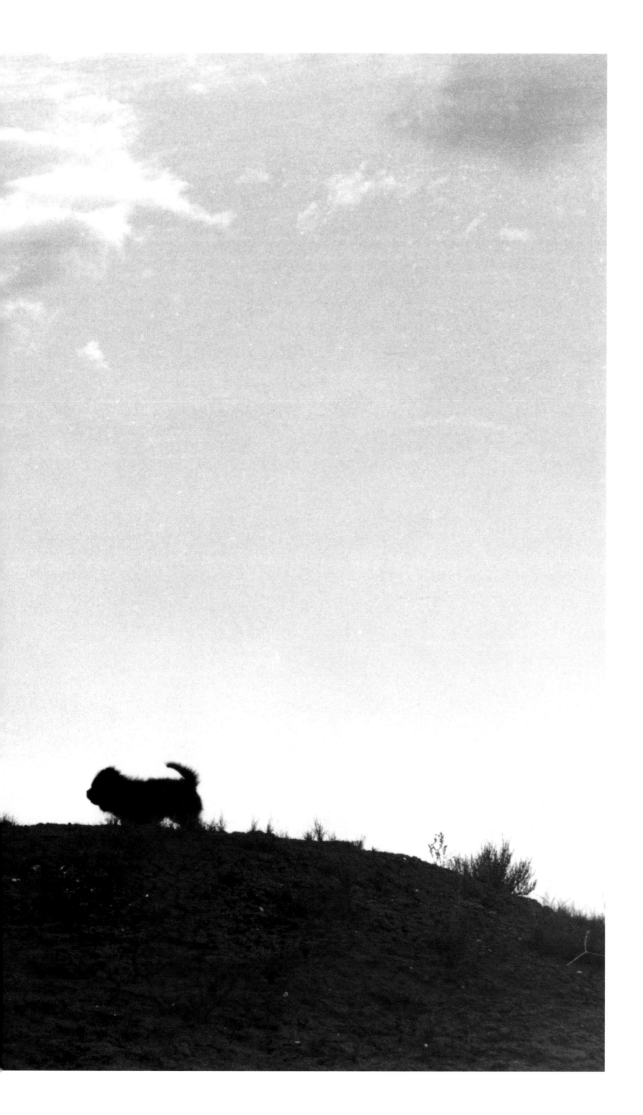

57 Evening walk,
Ghost Ranch, 1966

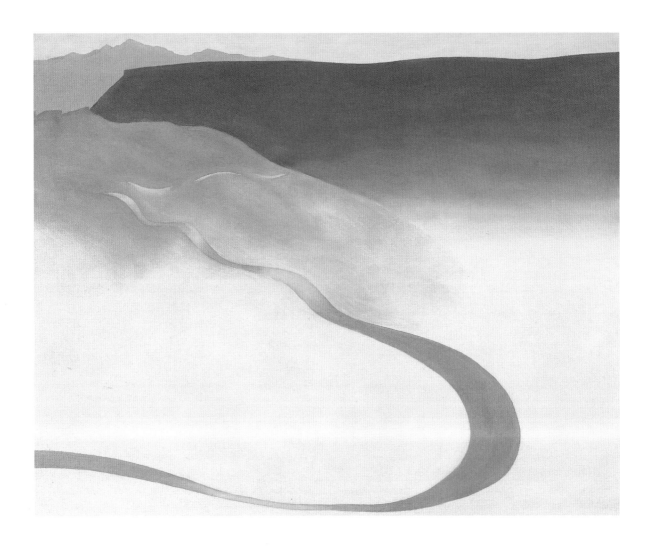

58 *Road to the Ranch*, 1964
Curtis Galleries, Minneapolis, MN
61 x 75,9 cm

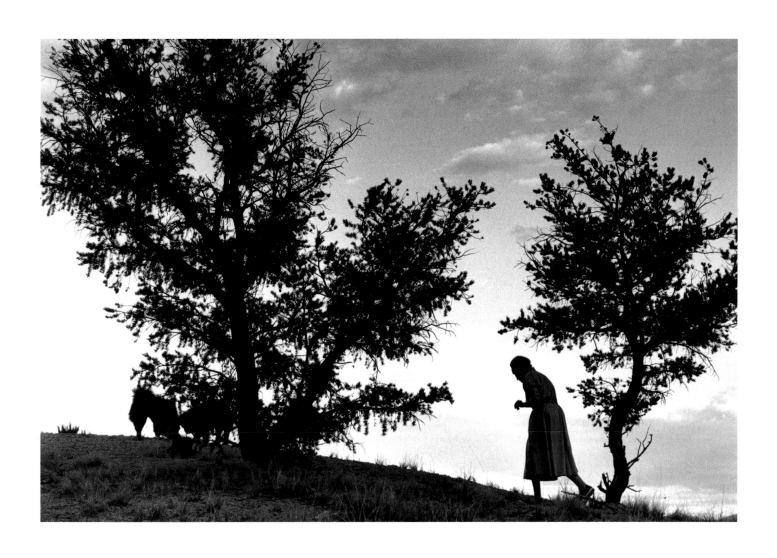

59 Evening walk, Ghost Ranch, 1966

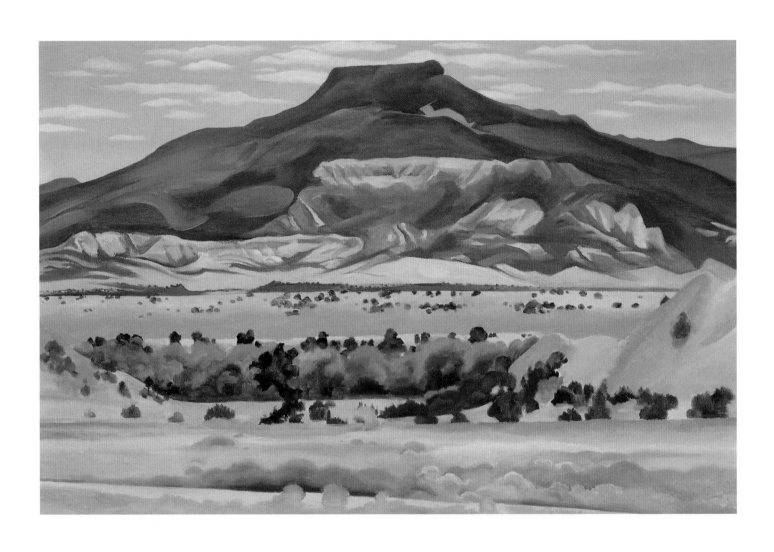

60 *My Front Yard, Summer*, 1941
Georgia O'Keeffe Museum, gift of the Georgia O'Keeffe Foundation
50,8 x 76,2 cm

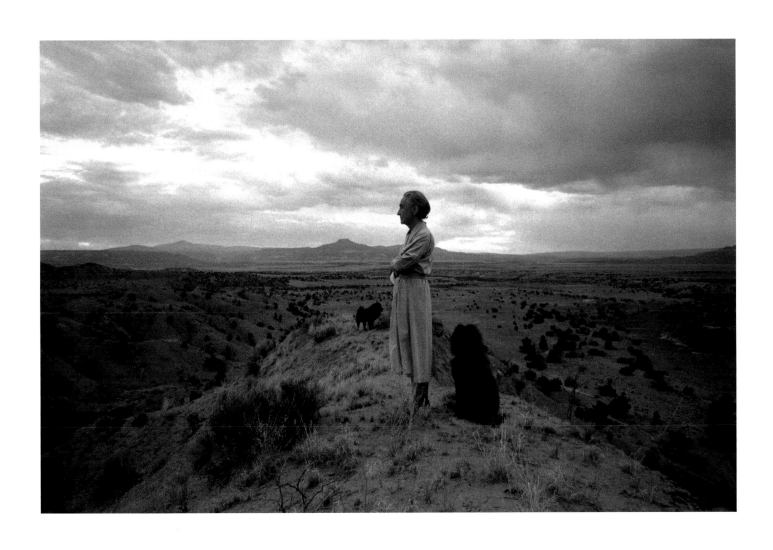

61 Evening walk, Ghost Ranch, 1966

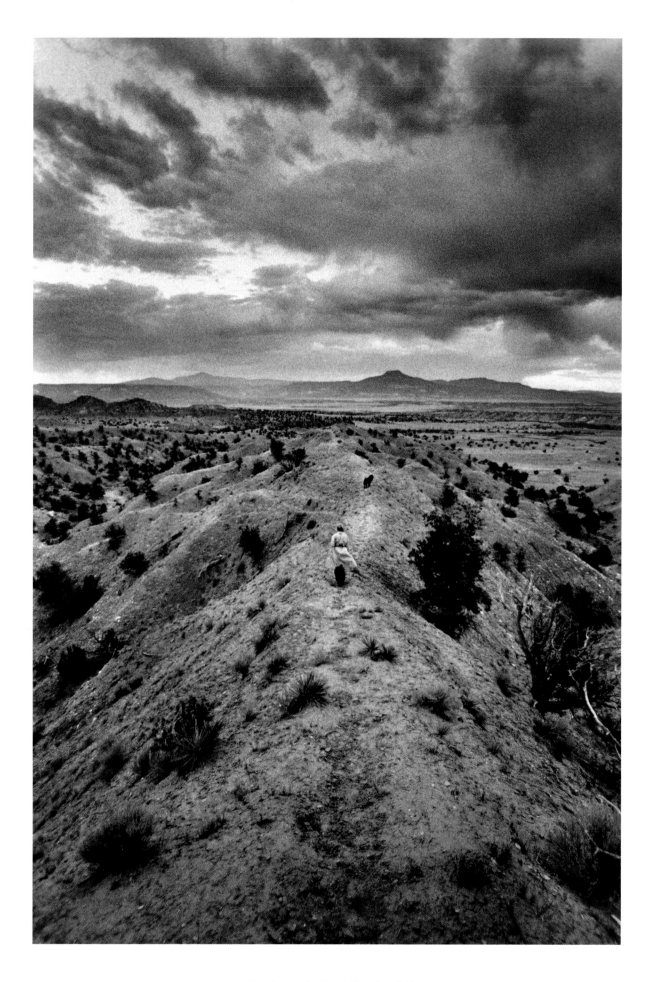

62 Evening walk, Ghost Ranch, 1966

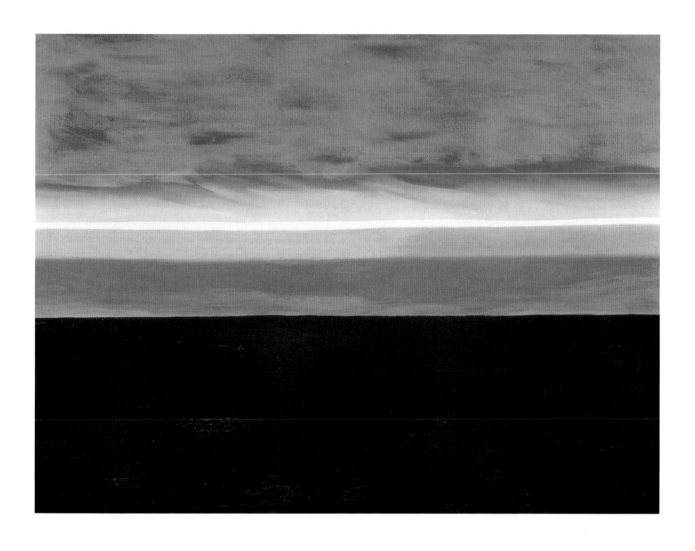

63 *The Beyond*, 1972
Georgia O'Keeffe Museum, gift of the Georgia O'Keeffe Foundation
76,2 x 101,6 cm

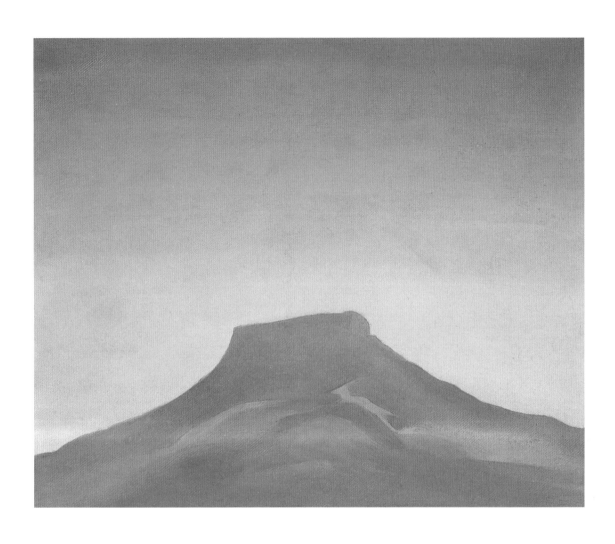

64 *Pedernal, New Mexico*, 1936
Private Collection
25,7 x 30,8 cm

Biographies

GEORGIA O'KEEFFE was born on 15 November 1887, the second child of a farming couple, near Sun Prairie, Wisconsin. In 1905, she began her studies at the Art Institute of Chicago, continuing in New York from 1907 at the Art Students' League. In New York, she visited Alfred Stieglitz's '291' gallery for the first time. Stieglitz was already a famous photographer, and in his gallery he supported European and American avant-garde art.

Periods of illness, and the need to earn a living, prevented Georgia O'Keeffe from pursuing her studies systematically. She worked as a commercial artist in Chicago, and taught at universities and colleges in Virginia, South Carolina, and Texas; but she kept in touch with the '291' gallery throughout this period. In 1917, Stieglitz showed her first one-person exhibition – with charcoal drawings and water-colours – and began his large-scale photographic project of producing a 'total portrait' of Georgia O'Keeffe, which he continued until 1937. It ultimately included over 300 shots.

Thanks to financial support from Stieglitz, Georgia O'Keeffe was able to devote herself entirely to her painting from 1918 onwards. She moved to New York, where Stieglitz put on her first large exhibition, with 100 paintings, at the Anderson Galleries in 1923. They married in 1924. From then on, she regularly exhibited her current work in Stieglitz's various galleries, at the Intimate Gallery (1925–1930) and 'An American Place' (1930–1950). During the 1930s, her name became familiar well beyond the circle of artists around Stieglitz. She met with increasing public and official recognition, receiving many prizes and honorary degrees. In 1934, the Metropolitan Museum purchased its first painting by her; in 1943, the Art Institute of Chicago held its first exhibition of her work; and in 1946, the Museum of Modern Art organized a large-scale retrospective, its first one-person exhibition devoted to a woman.

The New Mexico landscape had fascinated Georgia O'Keeffe ever since she first travelled through it in 1917. From 1929 on, she spent the summer in New Mexico every year, from 1934 at Ghost Ranch, where she bought a house and some land in 1940. Five years later, she also purchased a ruined adobe house in the neighbouring village of Abiquiu, and put in several years of renovation work to make it inhabitable. After Alfred Stieglitz's death in 1946 and the settlement of his estate, she moved to New Mexico permanently, living and working there for nearly four more decades – with breaks for trips that she made all over the world.

She died in Santa Fe in 1986, shortly before her ninety-ninth birthday.

JOHN LOENGARD was born in New York City in 1934. He received his first assignment from *Life* in 1956, while still an undergraduate at Harvard, and joined the magazine's staff in 1961.

During the 1960s, *American Photographer* hailed him as '*Life's* most influential photographer'. Many of the pictures he took during that period, including his photographic essays 'The Shakers' and 'Georgia O'Keeffe', are now considered classics of their genre.

In 1973, Loengard was appointed picture editor of the ten semi-annual *Life Special Reports*, after the magazine ceased weekly publication in 1972. He was instrumental in the rebirth of *Life* as a monthly in 1978, and served as its picture editor until 1987. He is still one of the magazine's contributing photographers. It was under his direction that *Life* won the first award for 'Excellence in Photography' ever made by the American Society of Magazine Editors, in 1986.

Pictures Under Discussion, a book of his own photographs, won the Ansel Adams Award for excellence in photographic books in 1987. Further publications of his work in book form followed: *Life Classic Photographs* (1988), *Life Faces* (1991), his homage to the photographic negative, *Celebrating the Negative* (1994), and *As I See it* (2005).

The publishers would like to thank Agapita Judy Lopez, the director of the Georgia O'Keeffe Foundation, Abiquiu, for her kind assistance in creating this book.

The paintings are reproduced with the kind permission of the following institutions and owners: © The Art Institute of Chicago, Alfred Stieglitz Collection, gift of Georgia O'Keeffe 1947.712: plate 20, © The Art Institute of Chicago, Alfred Stieglitz Collection, bequest of Georgia O'Keeffe, 1987.250.3: plate 41; © The Cleveland Museum of Art, bequest of Georgia O'Keeffe 1987.138: plate 3; © The Cleveland Museum of Art, bequest of Georgia O'Keeffe 1987.141: plate 22; © Curtis Galleries, Minneapolis, MN: plates 16, 58; © Collection Emily Fisher Landau, New York: plate 31; © Georgia O'Keeffe Museum, Gift of the Georgia O'Keeffe Foundation: plates 25, 60, 63; © Georgia O'Keeffe Museum, Santa Fe/Art Resource/ Scala, Florence: plates 1, 7, 26; © Indianapolis Museum of Art, Gift of Anne Marmon Greenleaf in memory of Caroline Marmon: plate 29; © The Metropolitan Museum of Art, Alfred Stieglitz Collection, 1952 (52.203): plate 47; © The Metropolitan Museum of Art, Alfred Stieglitz Collection, 1959 (59.204.2): plate 51; © Milwaukee Art Museum, Gift of Mrs. Edward R. Wehr, M1957.10: plate 43; © Museum Associates/LACMA, Gift of Georgia O'Keeffe Foundation: plate 49; © Museum of Fine Arts, Boston, Gift of William H. Lane Foundation, 1990.433: plate 39; © Museum of Fine Arts, Boston, Gift of William H. Lane Foundation, 1990.434: plate 45; © National Gallery of Art, Washington: plate 12; © Norton Museum of Art, West Palm Beach, Florida: plate 54; © Santa Barbara Museum of Art, Gift of Mrs. Gary Cooper: plate 5; © Private Collection: plates: 15, 33, 64.

We would like to thank John Loengard for his patience and for his friendly cooperation.
The photographs in this volume are available for sale. Please contact showroom@schirmer-mosel.com